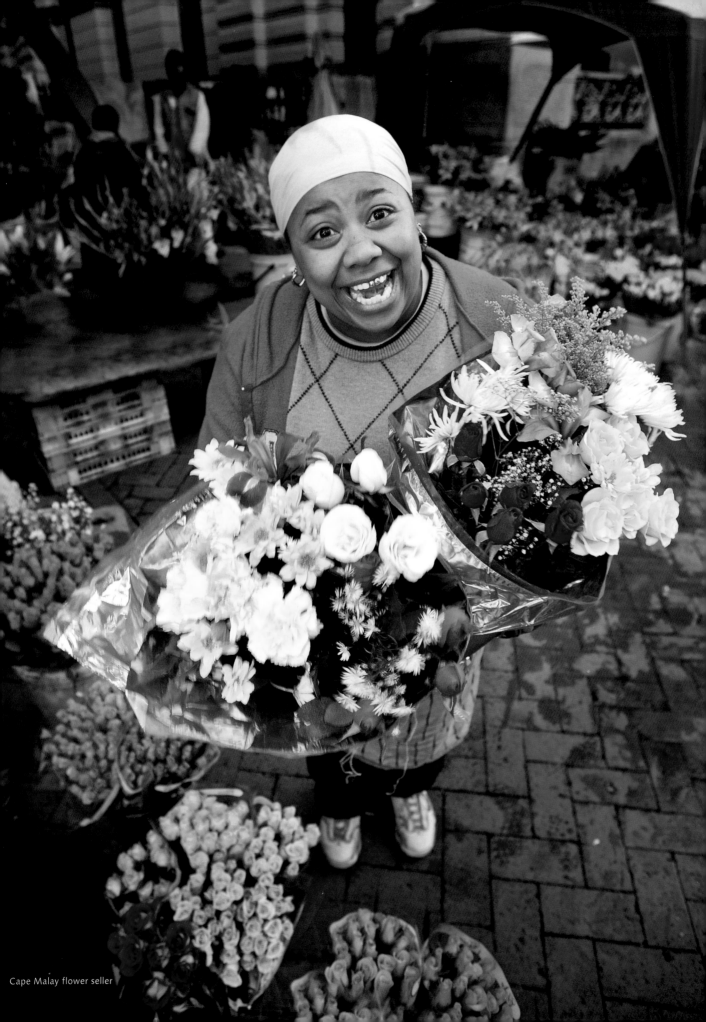

Cape Malay flower seller

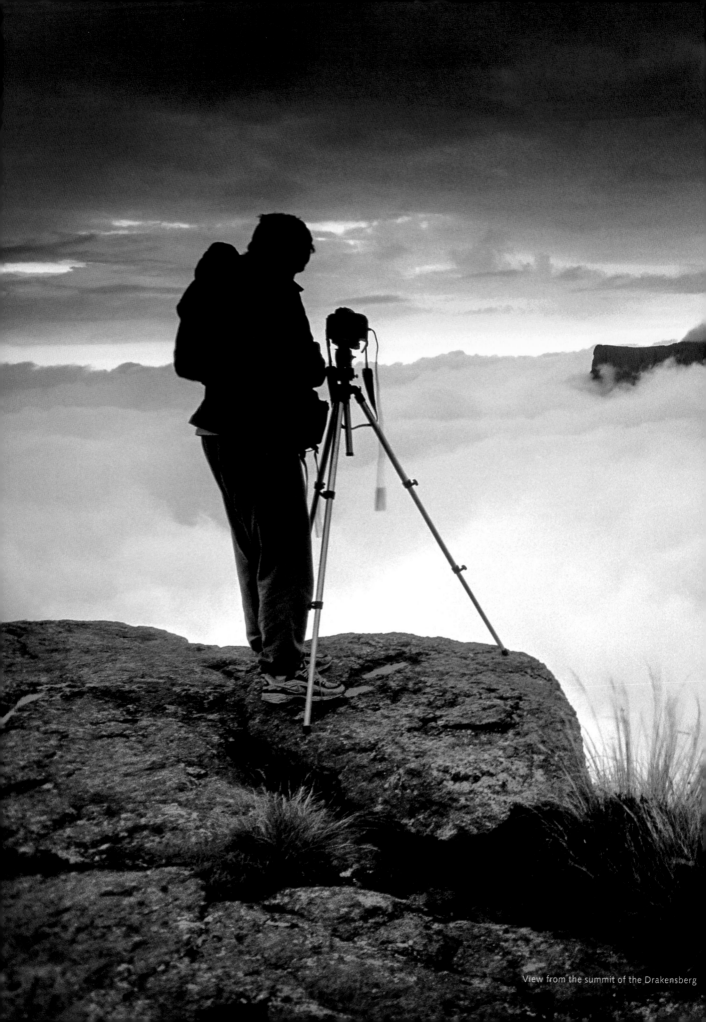

View from the summit of the Drakensberg

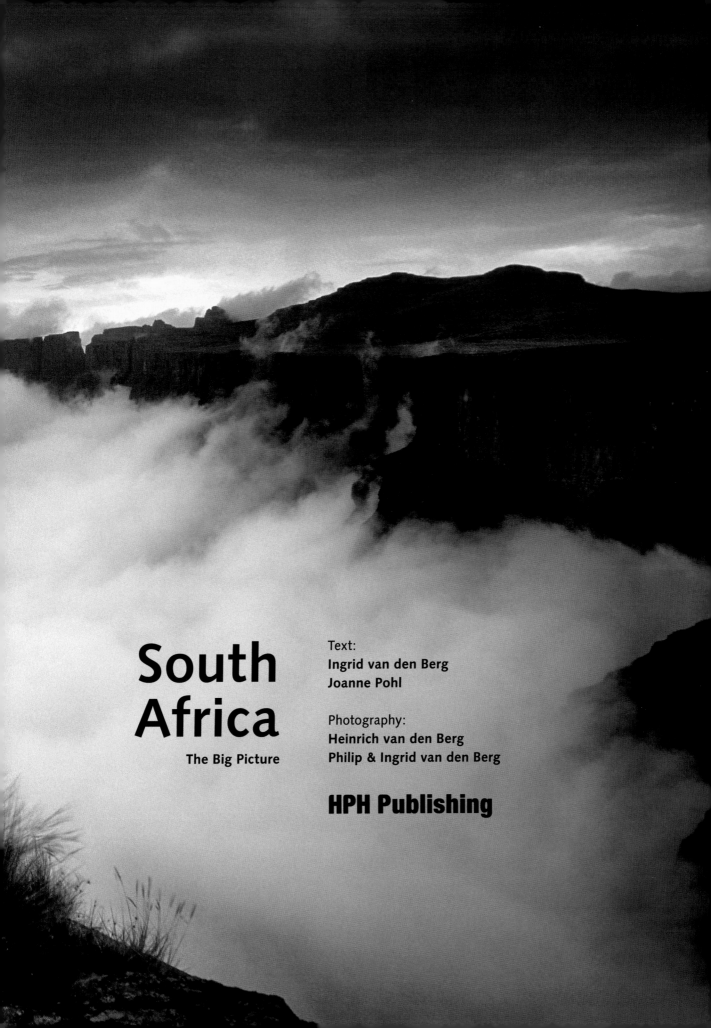

South
Africa

The Big Picture

Text:
Ingrid van den Berg
Joanne Pohl

Photography:
Heinrich van den Berg
Philip & Ingrid van den Berg

HPH Publishing

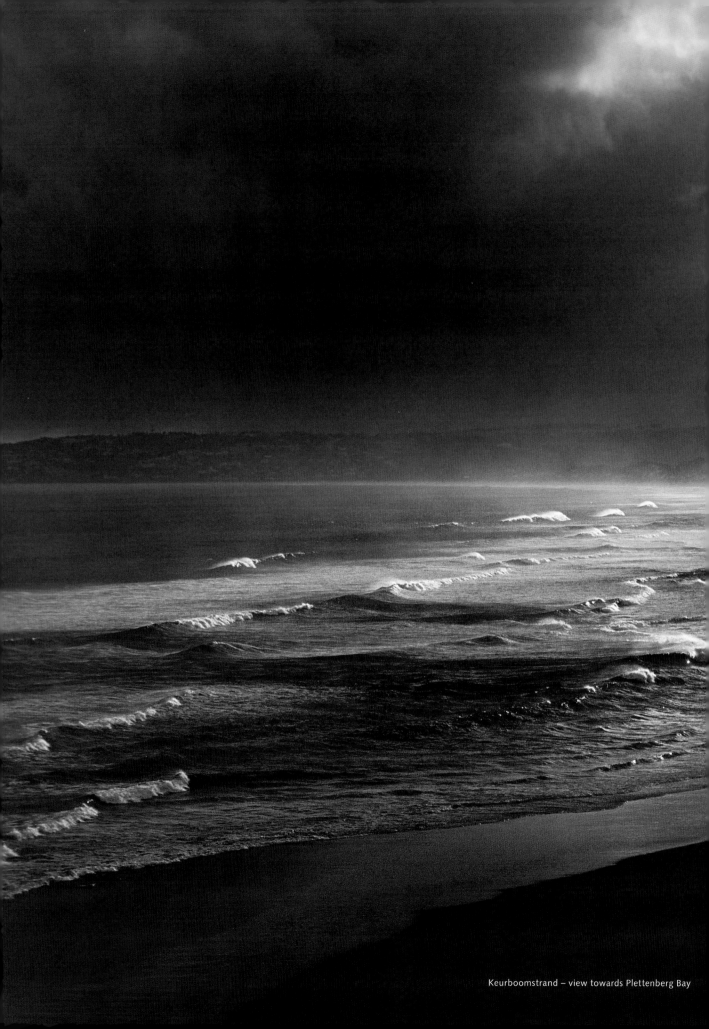

Keurboomstrand – view towards Plettenberg Bay

Table Mountain

Contents

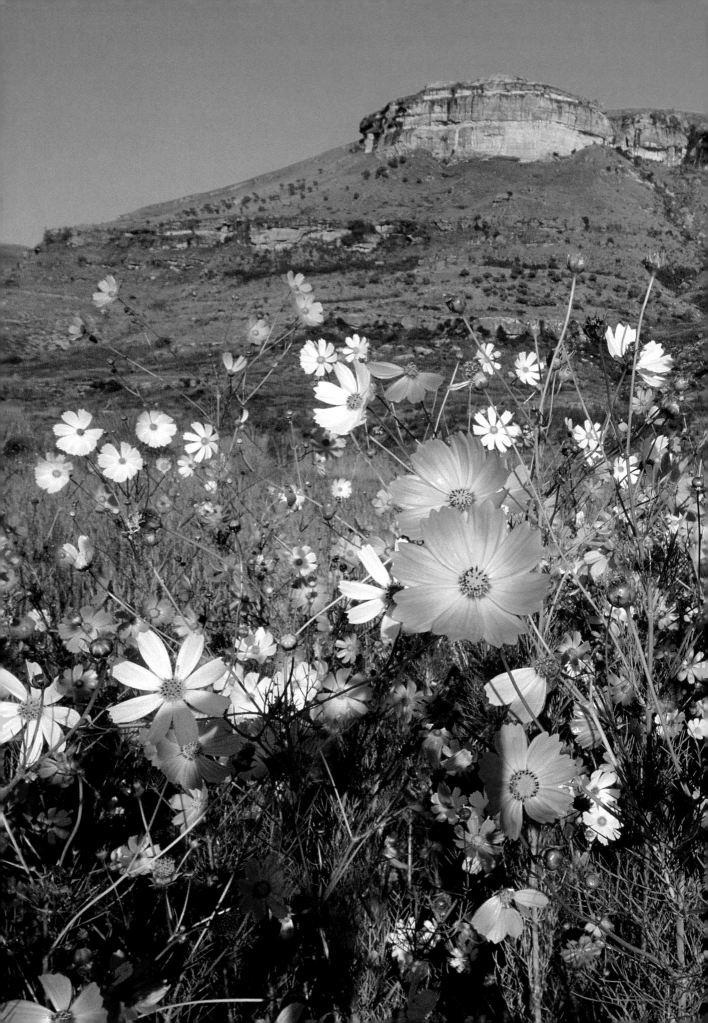

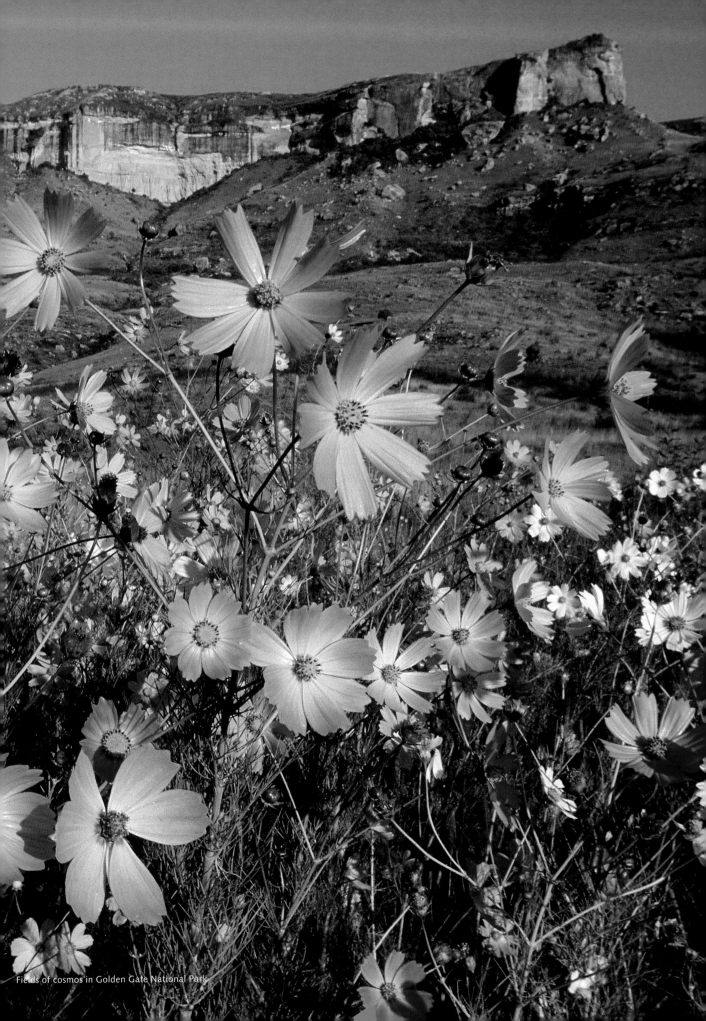

Fields of cosmos in Golden Gate National Park

South Africa

Area:
1.2 million km²

Population:
Over 56 million

Lingua franca:
English

Native languages:
isiZulu 22.7% isiXhosa 16% Afrikaans 13.5%
Sepedi 9.1% English 9.6% Setswana 8%
Sesotho 7.6% Xitsonga 4.5% siSwati 2.5%
Tshivenda 2.4% isiNdebele 2.1%
Others (including sign language 2%

Capital cities:
Administrative: Pretoria
Legislative: Cape Town
Judicial: Bloemfontein

Provinces:
Eastern Cape, Free State, Gauteng,
KwaZulu-Natal, Limpopo, Mpumalanga,
Northern Cape, North West, Western Cape

Transkei woman carrying grass for thatching

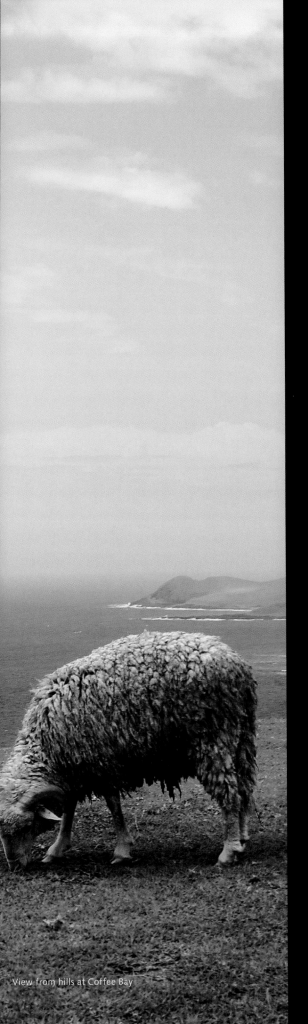

View from hills at Coffee Bay

Eastern Cape

Area:
169 580km², 13.9% of South Africa

Population: 7 million

Capital: Bhisho

Principal languages:
IsiXhosa 78.8% Afrikaans 10.6%
English 5.6%

The Sunshine Province

Location: South-eastern part of South Africa
Famous for: The country's highest sand dunes, cultural and ecological diversity and numerous shipwreck sites
The world's highest bungee jump at Bloukrans
Significance: Sheep, angora and cattle farming
The first, and still important, car manufacturing centre in South Africa
South Africa's only river port at East London

Rich in cultural history and ecological diversity, the Eastern Cape is a province of great beauty and contrasts. The scenery varies from the country's deepest gorges to the highest sand dunes; from indigenous forests to semi-arid Karoo landscapes; and from shipwrecking rocky shores to sandy beaches.

The cities of Port Elizabeth and East London are leaders in the economy of the province. Situated at the mouth of the Buffalo River, East London is the country's only river harbour. Also called the Buffalo City, it has seen considerable growth in recent years.

The inland towns have a special ambience reflecting their varied historic and cultural origins. There is Grahamstown, known as the 'City of Saints' with more than 40 churches, a typical British settlement. Berlin, Stutterheim and Potsdam are testimony to the influence of German settlers. Then there are the typical Karoo towns of Willowmore, Cradock, Queenstown and others with their extensive sheep farming. The rural village of Qunu in the Transkei is Nelson Mandela's childhood home.

Interesting to know:
Apart from the Tsitsikamma, Addo, Mountain Zebra and Camdeboo National Parks, there are several provincial and private game reserves in the Eastern Cape.

Sterkfontein dam

Free State

Area:
129 480km², 10.6% of South Africa

Population: 3 million

Capital: Bloemfontein

Principal languages:
Sesotho 64.2% Afrikaans 12.7%
isiXhosa 7.5% Tswana 5.2%
isiZulu 4.4% English 2.9%

Granary Province

Location:	The central province, set in the heart of South Africa
Typical features:	Flat or gently undulating scenery
Mainly high altitude grassland	
Spectacular sandstone cliffs in the north-east	
Famous for:	Agriculture, especially maize
Mining on the Goldfields Reef |

The Free State lies on the Karoo Sequence, a formation of rocks made up of shale, mudstone, sandstone and Drakensberg basalt. It is also a high-lying province approximately 2 000m above sea level.

Also known as South Africa's breadbasket, the Free State produces almost three-quarters of the country's grain on more than 30 000 farms. Cultivated land makes up 3.2 million hectares, with grazing taking up about 8.7 million hectares. The Ficksburg area is well known as the country's top cherry producer, as well as home to the two largest asparagus farms. Besides maize, which forms South Africans' main staple food and is predominantly farmed in the so-called maize triangle, the province's farms also produce sunflowers, wheat, sorghum, soya, and almost half of the country's potato crop.

The province is rich in minerals, which include gold, diamonds, silver, uranium, bentonite and coal. As an industry, mining is the largest employer in the province, and the 400km-long Goldfields Reef extends from Gauteng into the Free State. One of the country's two gold refineries, Harmony Gold Refinery, is found in Welkom.

Interesting to know:
The Vredefort Dome, a World Heritage Site, is situated in the Free State. Formed some two billion years ago, it is the oldest and largest known meteorite impact site in the world.

Gauteng

Area:
17 010km², 1.4% of South Africa

Population: 13.2 million

Capital: Johannesburg

Principal languages:
IsiZulu 19.8% English 13.3%
Afrikaans 12.4% SeSotho 11.6%

Metropolitan Province

Location: In the middle of the country, north of the Free State
Significance: Site of O R Tambo International Airport
Economic heart of South Africa
Most vibrant business environment
Ecological and cultural diversity
High altitude, pleasant summers, cold winters

Gauteng is not only the most prosperous province, but is also the smallest in area, with the highest population density. It is at present the fastest growing province, with a population increase of about 100 000 per year.

Being the heartbeat of a country with healthy economic growth, it beats fast and strong, providing a vibrant business environment and many opportunities for growth in all sectors. Not only does Gauteng contribute 33% of the South African economy, but also 10% of the Gross Domestic Product of the entire African continent.

Although Gauteng was built on the wealth of underground gold (40% of the world's known gold is found here), the economy has since diversified, with more sophisticated sectors such as finance and manufacturing becoming strongly established, and therefore gold mining is no longer the mainstay. The province is essentially a mega-city – 97% of its population live in urban centres.

Interesting to know:
Gauteng **is a Sesotho word meaning 'at the place of gold' – a locative derived from the Afrikaans word** *goud* **(gold). The initial 'g' in both words is pronounced as 'ch' in the Scottish 'loch'. The Zulus took the English word 'gold' and used their locative form** *eGoli* **to name Johannesburg, pronounced e (as in 'egg') GORE lee.**

FNB stadium

KwaZulu-Natal

Area:
92 100km^2, 7.6% of South Africa

Population: 10.9 million

Capital: Pietermaritzburg

Principal languages:
IsiZulu 77.8% English 13.2%
isiXhosa 3.4% Afrikaans 1.5%

Garden Province

Location: The south-eastern part of the country, bounded by Swaziland and Mozambique to the north, Lesotho to the west and the Mthamvuna River in the south

Famous for: Sunny holiday beaches
Wildlife and game reserves
A spectacular mountain range
The beautiful Midlands
Two World Heritage Sites

KwaZulu-Natal is one of the most beautiful provinces in South Africa. Not only does it have a rich cultural diversity, but it also offers outstanding scenery, wildlife and wilderness experiences. The first two World Wildlife and Cultural Heritage sites declared in South Africa are in this province.

The Drakensberg range, with its 300-metre high peaks, forms the border between KwaZulu-Natal and the Kingdom of Lesotho. Within a distance of 250km the land descends to the Indian Ocean where the continental shelf vanishes into the sea.

Interesting to know:
KwaZulu-Natal covers only about 8% of South Africa's land area but almost two-thirds of the country's tree species are found here. This is 11 times more than all those found in the whole of Europe. As for the floral diversity – KwaZulu-Natal has some of the richest floral regions in Africa. Two of the world's centres of plant diversity or 'hotspots' occur here – areas of global botanical importance with a high diversity and large numbers of endemic or threatened species with social, economic, cultural and scientific importance.

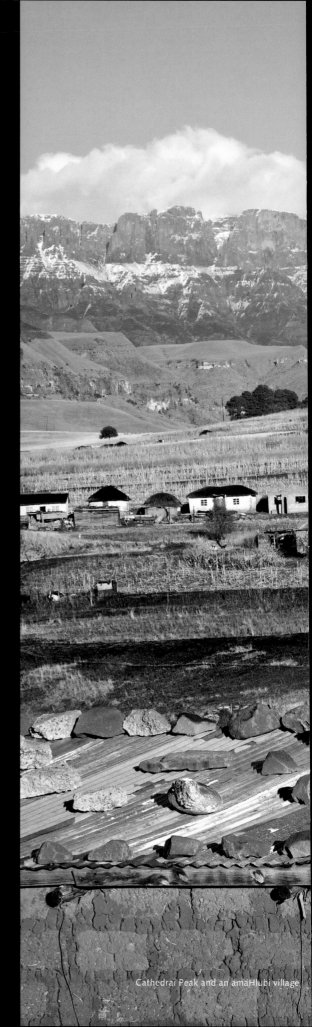

Cathedral Peak and an amaHlubi village

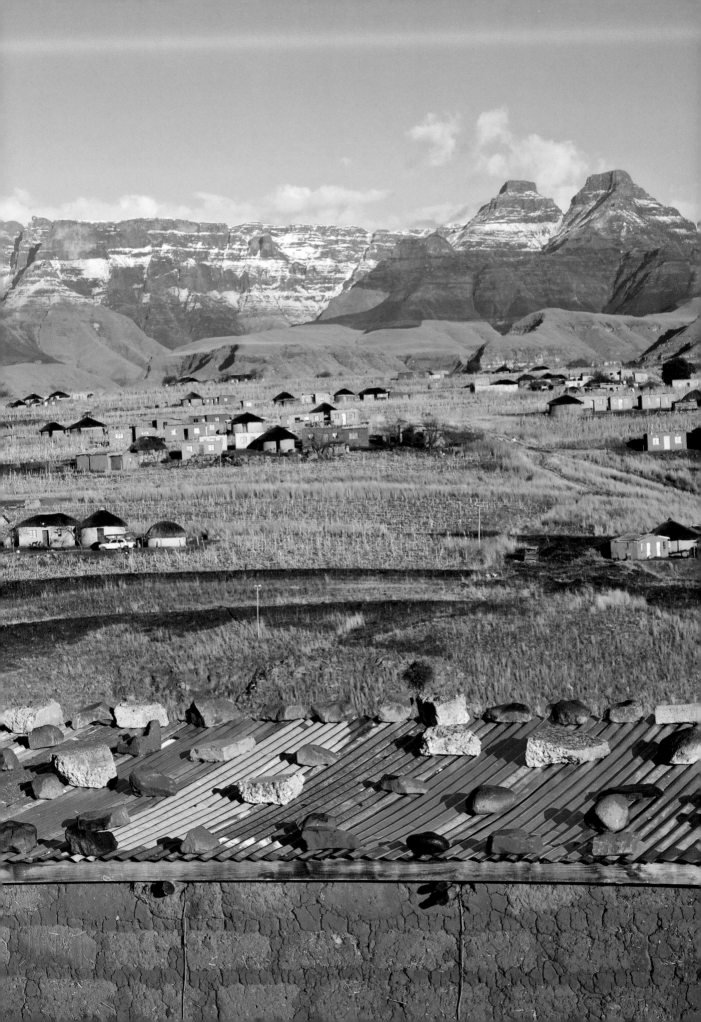

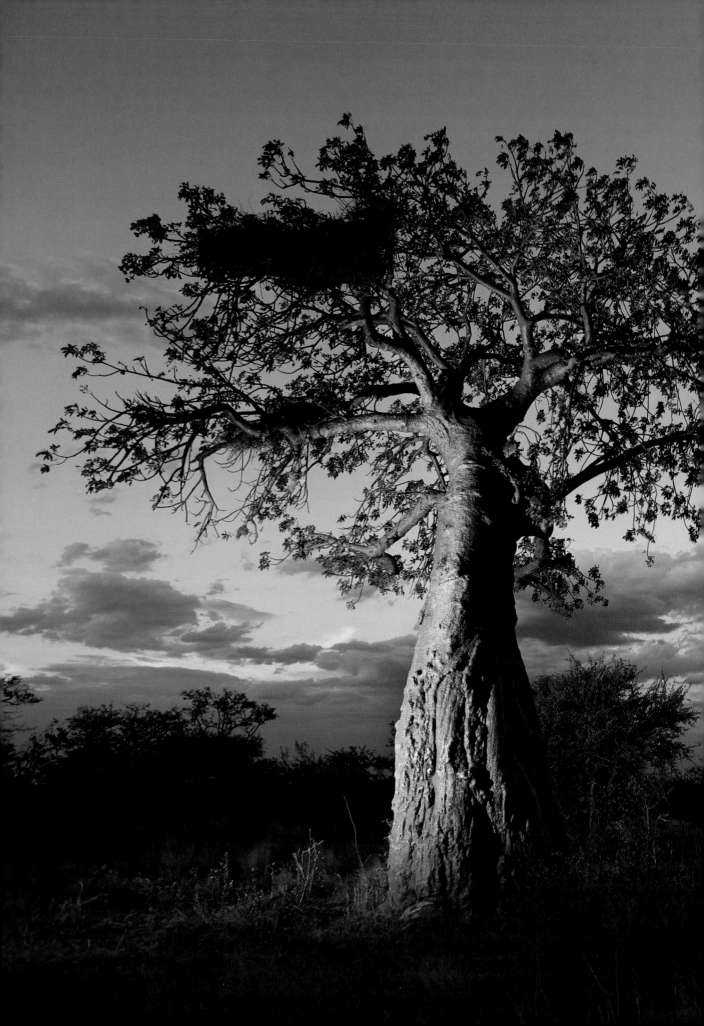

Limpopo

Area:
123 910km^2, 10.2% of South Africa

Population: 5.7 million

Capital: Polokwane

Principal languages:
Sesotho 52.9% Xitsonga 17%
Tshivenda 16.7% Afrikaans 2.3%

 Friendly Province

Location:	The northernmost province of South Africa
Significance:	The greatest fruit producer in the country
	A top tourism destination
Famous for:	The remains of ancient civilisations
	Unique cultures – Venda and Lemba
	The world-renowned Kruger National Park (north)
	Mopani worms – a delicacy enjoyed by locals

Limpopo province takes its name from the mighty Limpopo River that curves along the northern edge of the province and forms the border between South Africa and Zimbabwe. The province is home to numerous cultural and historical sites, including the Mokopane area. In this district are the Makapan Caves, which are famous fossil sites, as well as the Makapan Valley, a significant place in the 150-year history of the Ndebele people and their resistance wars.

The Thabazimbi area is home to numerous game reserves, making it one of the fastest-growing ecotourism areas in South Africa. The waterberg mountain range is another wildlife hotspot of several malaria-free game reserves. Modjadjiskloof near Tzaneen, home of the legendary Rain Queen, also has the world's largest concentration of the cycad species *Encephalartos transvenosus*, commonly known as the Modjadji palm.

Interesting to know:
In the most north-eastern part of the province, where the borders of South Africa, Zimbabwe and Mozambique meet, is Crooks' Corner, a place where big game poachers used to make camp before venturing into the wild landscapes of what is today the Kruger National Park.

Baobab at Mapungubwe National Park

Mpumalanga

Area:
79 490km², 6.5% of South Africa

Population: 4.2 million

Capital: Nelspruit

Principal languages:
SiSwati 27.7% isiZulu 24.1%
Xitshonga 10.4% isiNdebele 12.1%
Sesotho 9.3%

Sunrise Province

Location: In the north-eastern part of South Africa
Typical features: Above the escarpment is cool highveld, below the escarpment is the lowveld/bushveld
Famous for: The Kruger National Park and other game and nature reserves
Sub-tropical fruit, sugar cane, maize and timber
Scenic beauty

The word *Mpumalanga* means 'east' or literally 'place of the rising sun'. The Mpumalanga Drakensberg mountain range bisects the province into the western highlands and the eastern lowlands – known as the highveld and lowveld respectively. The lowest and easternmost part of the latter is also called the bushveld. The lowveld is covered by savannah and has a hot subtropical climate. The dividing escarpment exceeds 2 000m in many places and is covered with alpine grasslands. The far eastern border of the country is formed by the Lebombo mountain range, separating South Africa from Mozambique.

Rich in natural resources, Mpumalanga is the main forestry area of the country, and its plantations feed the paper industry. The province also boasts large coal deposits and wildlife in scenic game reserves (including the southern half of the world-renowned Kruger National Park). The gold rushes of the 1870s and 1880s were at Barberton and Pilgrim's Rest. Along the escarpment, impressive waterfalls, deep potholes and the world's third largest canyon offer breathtaking scenery.

Interesting to know:
Mpumalanga province, with a range of terrain from highveld wetlands to sub-tropical areas, has abundant bird life, and is a favourite destination for birders.

Guests on a game drive at Sabi Sand

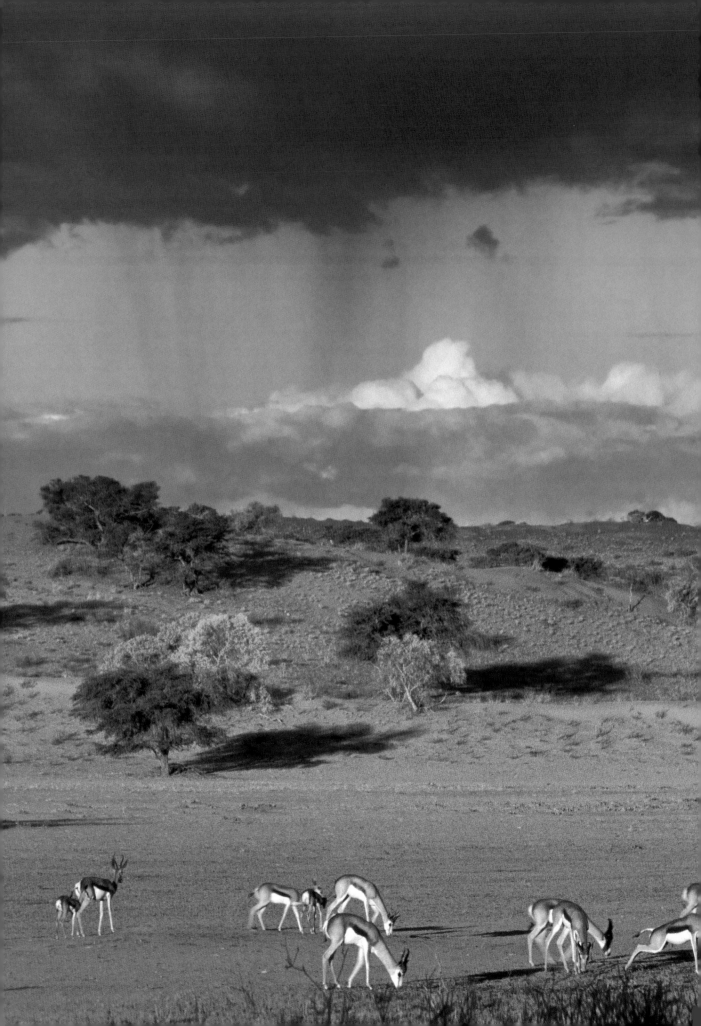

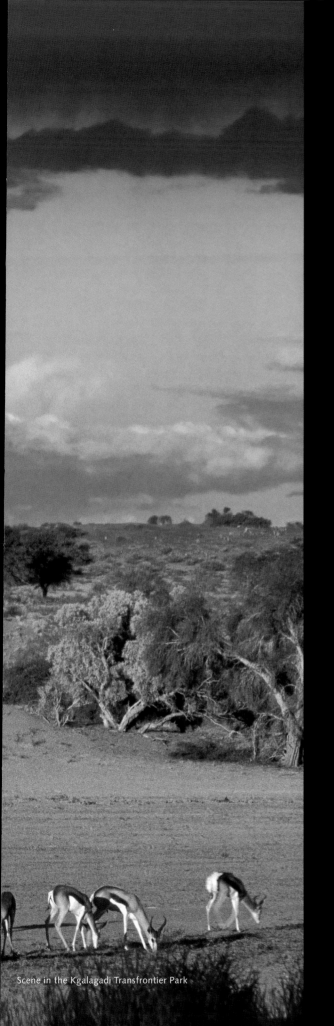

Scene in the Kgalagadi Transfrontier Park

Northern Cape

Area:
361 830km², 29.7% of South Africa

Population: 1.2 million

Capital: Kimberley

Principal languages:
Afrikaans 53.8% Setswana 33.1%
isiXhosa 5.3% English 3.4%
Sesotho 1.3%

 Arid Province

Location: Far north-west of South Africa
 Borders Namibia and Botswana
Significance: The largest province – 30% of South Africa's
 surface area – but also the most sparsely
 populated
Famous for: Two Transfrontier National Parks (!Ai-!Ais/Rich-
 tersveld and Kgalagadi)
 National Parks (Namaqua, Tankwa and Augrabies)

The Orange River is the Northern Cape's most significant asset, as it sustains the province's agricultural pursuits and washes alluvial diamonds to the west coast. Upington is the great centre of karakul sheep farming and the country's dried fruit industry – its dates and raisins are exported worldwide. The province is also the most northerly winemaking region in South Africa.

The town of Kuruman, in the middle of the dry Kalahari basin, is famous for the 'Eye of Kuruman', a perennial freshwater spring discovered in 1801, which produces between 20 and 30 million litres a day. Sutherland, in the south of the province, is the home of the Southern African Large Telescope (SALT) and is the largest astronomical observatory in the southern hemisphere.

The Northern Cape is also known for its mineral wealth, and is a significant producer of diamonds. It is also a province of agricultural industry and of numerous game reserves, both public and private.

Interesting to know:
The dry Kalahari and the Great Karoo may seem inhospitable at first glance, but once you've met their people, seen the countryside after rains and bent down to shake sand out of your shoes, you become addicted. The semi-desert keeps luring you back time and again.

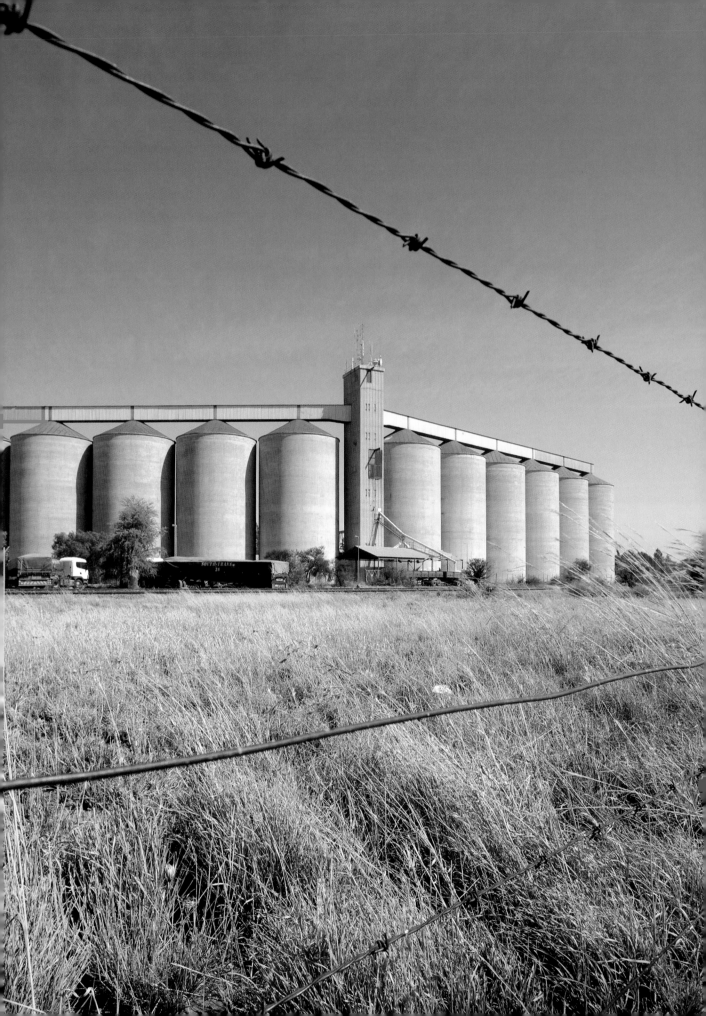

Massive grain silos are a typical feature of the province

North West

Area:
116 320km^2, 9.5% of South Africa

Population: 3.7 million

Capital: Mahikeng (formerly Mafikeng)

Principal languages:
Setswana 63.4% Afrikaans 9% Sesotho 5.8%
isiXhosa 5.5% Xitsonga 3.7%

 Platinum Province

Location: The North West province lies to the east of the
Kalahari Desert, north of the Free State, and west
of Gauteng
Its capital, Mafikeng, lies near the Botswana border
Significance: Rich in mineral deposits
Important agricultural centre
Vegetation mainly semi-arid savannah

The North West is a province of mineral and agricultural wealth, flat
landscape vistas, impressive mountains, wide skies and strong August
winds. 94% of South Africa's platinum is mined in the province's Bo-
janala Region. Known as the Bushveld Igneous Complex, the area sur-
rounding the towns of Rustenburg and Brits has the highest production
and richest reserves of platinum in the world.

More than 30% of North West's Gross Domestic Product comes
from mining, and besides platinum the province also yields diamonds,
granite, marble and copper. The southern part is a rich agricultural
area, characterised by the bright green and yellow maize and sun-
flower fields.

The Vaal River forms the southern border and for lovers of outdoor
pursuits offers angling and fly-fishing, whitewater rafting, canoeing,
hiking and mountain biking. The Bophirima Region is where much of
the livestock farming occurs, and is also where the Taung skull – one
of the most significant archaeological discoveries in the world – was
found in 1924.

Interesting to know:
**Pilanesberg, in the east of the province, is the site of an extraordi-
nary extinct volcano.**

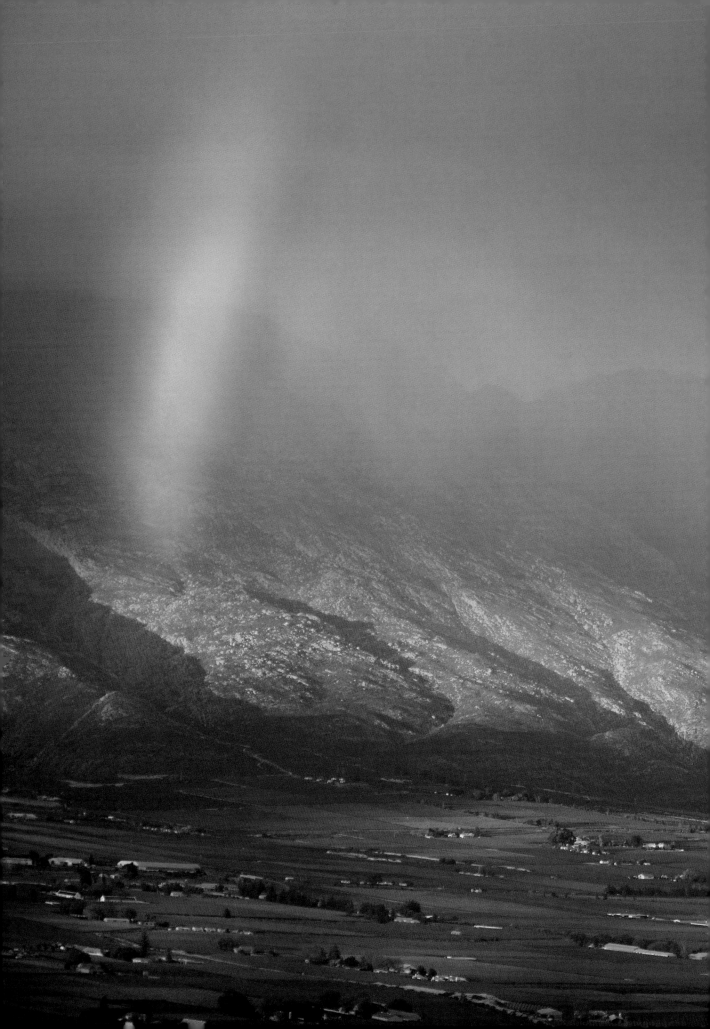

Hex River Valley

Western Cape

Area:
129 370km², 10.6% of South Africa

Population: 6.2 million

Capital: Cape Town

Principal languages:
Afrikaans 49.7% isiXhosa 24.7%
English 20.2%

 Province of Good Hope

Location: The southern tip of South Africa
Famous for: Scenic beauty
 Wine and wine routes
 The annual Cape Carnival
 Fynbos vegetation
 Table Mountain

The Western Cape is a cultural *mélange*, with descendants of people from all over the world. Over the centuries, people came from European countries such as Portugal, Holland, Germany, France, Britain and Prussia. From the East, they came from India, Batavia, Indonesia and Malaysia.

The land is one of contrasts; the semi-arid Karoo in its northern parts is a far cry from the beaches of the Cape Peninsula. Along the province's flat West Coast, commercial fishing abounds and small hamlets dot the landscape, while the scenic Garden Route meanders along the breathtaking southeastern coast.

The Western Cape is known for its vineyards and deciduous fruit. Sheep, canola and wheat farming is the agriculture of the hinterland. Saldanha, north of Cape Town, is the port through which most of South Africa's iron ore is exported, and Koeberg is the country's first nuclear power station.

Interesting to know:
The climate is largely Mediterranean, with mainly wet winters and dry summers. With the strong winds coming off the two oceans that flank this province (especially the legendary South-Easter which has been known to lift people off the ground), it is no wonder early seafarers called it the Cape of Storms.

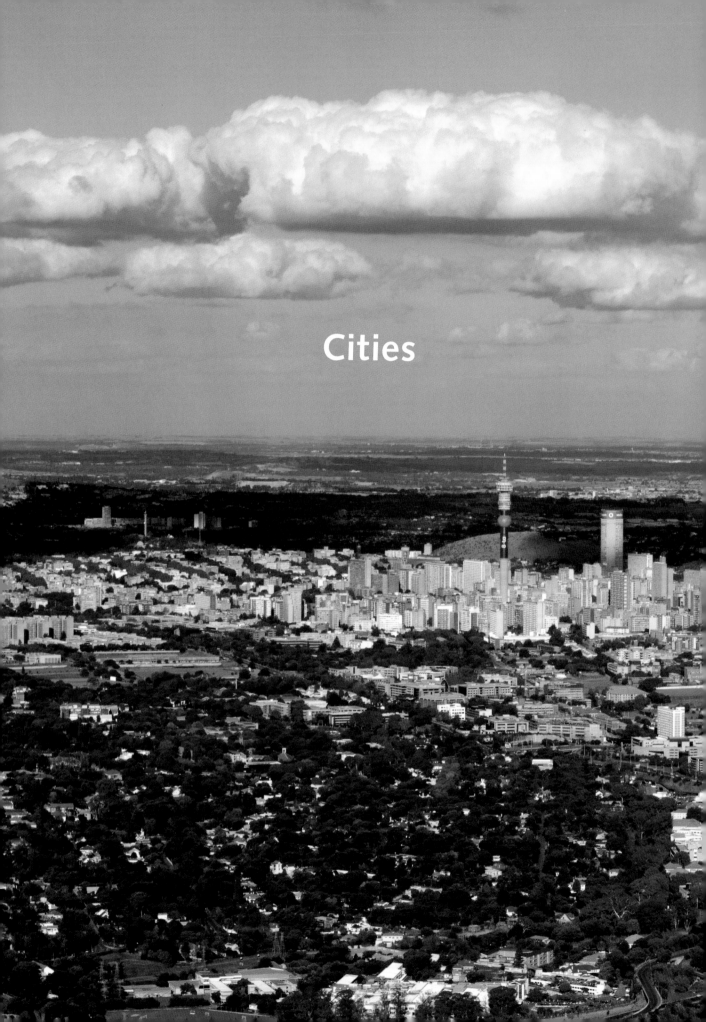

Cities

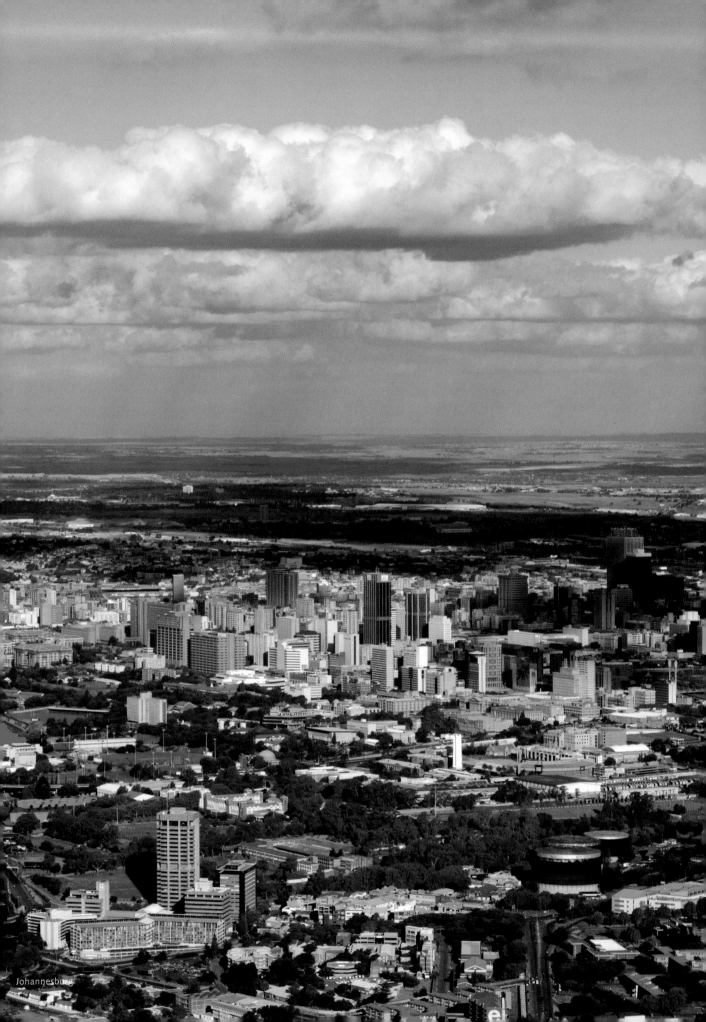

Johannesburg

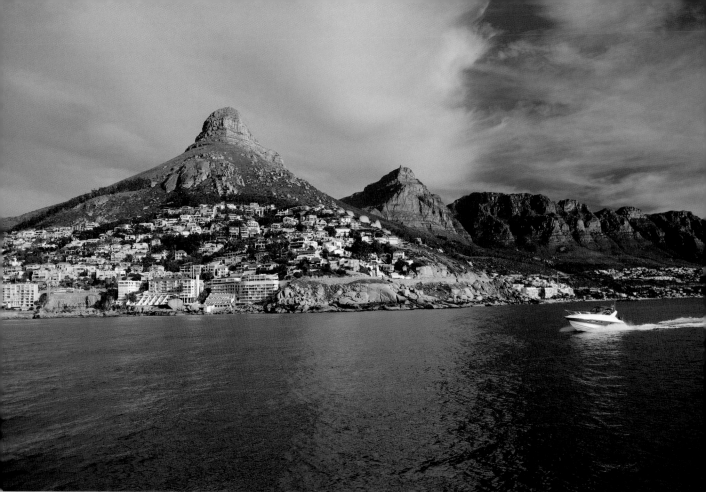

Signal Hill, Cape Town

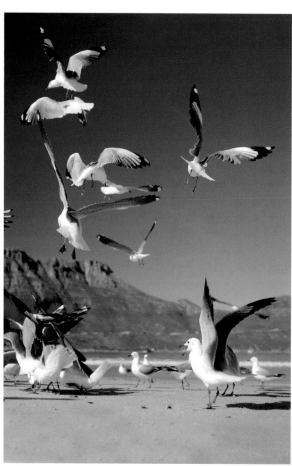

Hartlaub's gulls on the beach at Hout Bay

Van Riebeeck's Cape

Location: Present-day Cape Town
Also known as: The Cape of Good Hope
Significance: Established by Jan van Riebeeck in 1652
Voted as: One of the top tourist destinations in the world
The eighth most creative city in the world
A world-class events destination

Cape Town, also known as the Mother City or Tavern of the Seas, was the first place occupied by European settlers as part of the Dutch endeavour to secure a trading route to the East. Jan van Riebeeck was charged with establishing a secure settlement for the Dutch East India Company at the strategic Cape, where their ships could replenish their fresh food and water, en route to and from India.

After van Riebeeck's landing on 6 April 1652 the 'Fort de Goede Hoop' was built as a fortification for the base, and the settlement began to flourish. It grew from a simple rest stop to a well-equipped harbour with a pier, fruit orchards and vegetable gardens, a hospital and a shipyard. The Fort of Good Hope was replaced by the Castle of Good Hope, completed by 1679, which today still stands in Cape Town. The five bastions of the building are named after the main titles of William, Prince of Orange: Leerdam, Buuren, Catzenellenbogen, Nassau and Orange. The castle was declared a national monument in 1936, and is continually preserved.

Interesting to know:
The Cape is rich in history and clues harking back to the origins of the city. It was a port of arrival for countless settlers. In the 17th and 18th centuries, slaves from the East were brought in and to this day a strong Cape Malay culture is evident in Cape Town.

The Malay Quarter in the Bo-Kaap on the slopes of Signal Hill

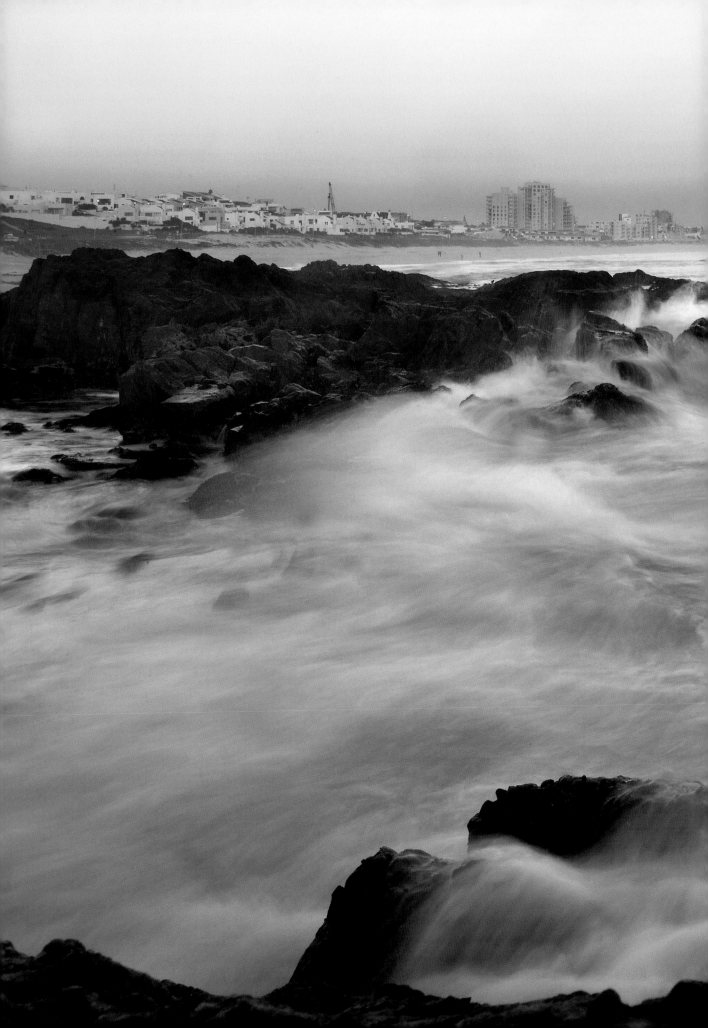

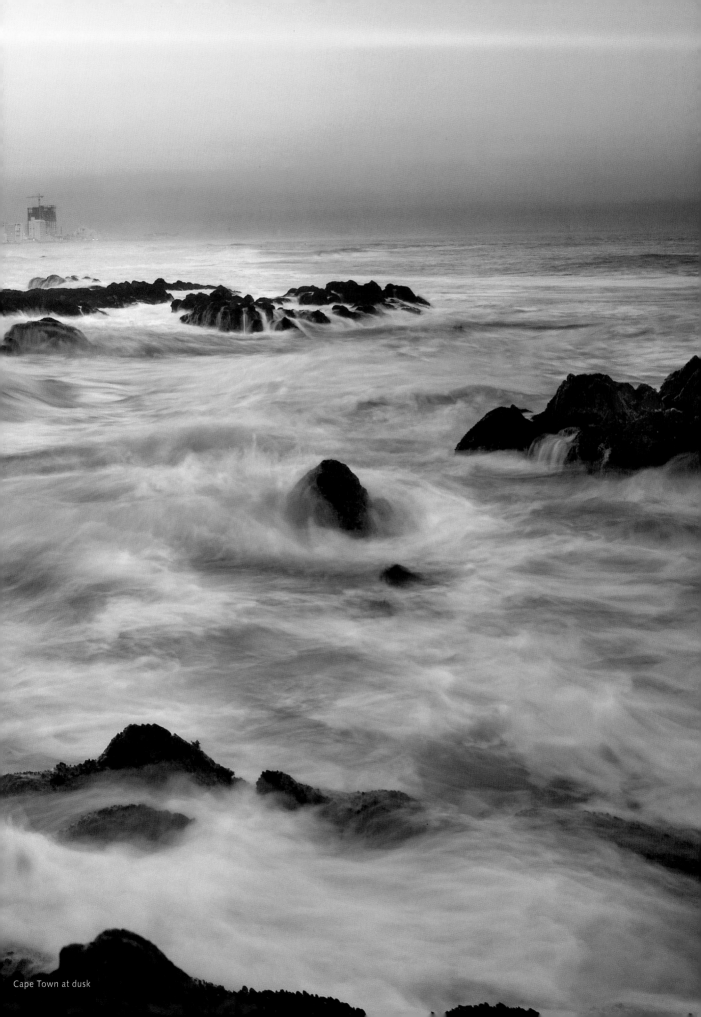
Cape Town at dusk

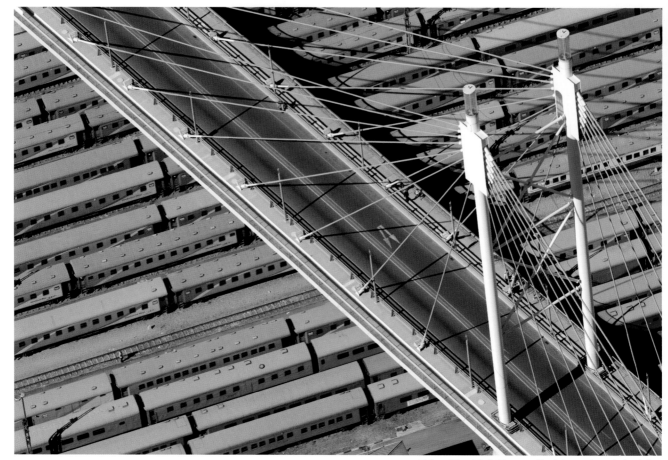

Nelson Mandela Bridge over the Johannesburg train station

City of Gold

Location: In the centre of Gauteng
Significance: Cosmopolitan city
Centre of country's economic development
Its wealth was built on the discovery of gold
Estimated population 3.2 million

Johannesburg is the capital of Gauteng – by far the largest city in South Africa and indeed, the whole of Africa. Also known as Joburg or Jozi, it is often called the 'New York of Africa' because of its similar urban sprawl linked by huge highway interchanges.

Everything seems to be bigger in Johannesburg, both the good and the bad. The Witwatersrand Reef holds the richest deposits of gold in the country, 600 tons of which are mined in a single year. The enormous mine dumps could be mistaken for mountains. Johannesburg also has the largest city-within-a-city (Soweto); huge shopping malls comparable with the best in the world; and centres of finance, fine art, museums, a zoological garden, music venues, and world-class restaurants. There are the ultra-wealthy but also the poorest of the poor.

The lakes and dams found within easy reach of the city provide numerous resorts for sports and entertainment. The Walter Sisulu National Botanical Garden boasts a 70m high waterfall and stunning displays of indigenous plants. The Apartheid Museum tells the story of apartheid through film, photographs and artefacts.

Interesting to know:
It all started early in the 19th century when a man named George Harrison first discovered the precious metal that was to become the main support of South Africa's economy and on which the great city was built.

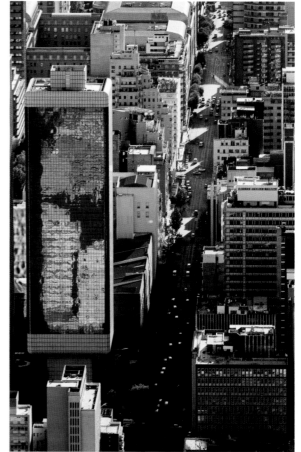

Johannesburg city centre

The Union Buildings, Pretoria

Jacaranda City

Location: About 55km north of Johannesburg
Significance: Various museums and national monuments
Buildings by famous architect Sir Herbert Baker
One of world's ten best zoological gardens

Known as the Jacaranda City because of its many trees that come into magnificent purple bloom in October and line its thoroughfares, Pretoria is a lovely, seemingly quiet city with a long, involved and fascinating history. It has succeeded in blending the old and the new and has seen many social and political changes.

The magnificent towers, amphitheatre and classical design of the Union Buildings, completed in 1913, are among Sir Herbert Baker's most impressive achievements. This is the administrative seat of the government and has been described as one of the finest government buildings in the world. The iconic Voortrekker Monument, which towers 61m above the crest of a hill, is an impressive memorial to the 19th century pioneers.

The Transvaal Museum has world-class natural history displays and is the home of Mrs Ples, the australopithecine fossil found at Sterkfontein in the Cradle of Humankind. The Cultural History Museum and the Smuts Museum in Irene, just outside town, are also worth a visit.

Interesting to know:
Prominently situated on a hilltop, the Voortrekker Monument can be seen from almost any location in the city. The massive granite structure is truly impressive and was built in honour of the Voortrekkers – the Dutch pioneers who left the Cape Colony between 1835 and 1854. The two most interesting features are the historical friezes and the cenotaph.

The Union Buildings, Pretoria

A mural in Soweto

Soweto

Location: South-west of Johannesburg
Significance: An urban area within the city of Johannesburg
Approximately 65% of Johannesburg's residents
live here

Soweto (the name sounds truly African, but it derives from **SO**uth **WE**st-ern **TO**wnships) is a city of contrasts: luxurious mansions across the road from tin shanties; high unemployment, yet friendly and cheerful people.

After 1994, the government launched a building programme for the poor to provide thousands with simple two-roomed houses, yet this was not enough to prevent illegal squatter camps from growing and spreading. But Soweto also has its better suburbs and has seen many economic improvements with the building of malls, hotels and entertainment centres, as well as a large number of institutions like schools and hospitals. Over the years it has become known as a centre for African urban culture and nightlife, and is credited with being the birthplace of kwaito – a hip-hop music style specific to South Africa. Soweto has become a major tourist attraction for those who want to experience the real African culture and lifestyle.

Most Sowetans don't own cars and rely on minibus taxis, buses and trains. Although they regard them as dangerous, the majority prefer to make use of the taxis because they are fast, cheap and will stop anywhere.

Interesting to know:
Soweto attracted the world's attention during the 1976 Soweto Uprising, when 10 000 students marched in protest against the government's enforced system of education, and 566 people were killed. The Hector Pietersen memorial is a 'must visit' when going to Soweto.

Hawker in Soweto

City of Flowers

Location: On the N1 midway between Johannesburg and Cape Town

Significance: Judicial capital of South Africa where the Supreme Court of Appeal sits
Capital of the Free State Province

Despite its location in a relatively arid region, the name *Bloemfontein* means 'fountain of flowers' in Afrikaans and Dutch. To this day, it lives up to this name. The King's Park Rose Garden has over 4 000 rose bushes; thousands more are planted along the street verges as well as in private gardens, and in October at the height of the flowering season, the annual rose festival attracts thousands of visitors.

Bloemfontein was originally founded as a British outpost in 1846 to act as a fort in the then Transoranje region. The city has a proud architectural heritage, evident in the national monuments, museums and government buildings that line its streets. But it is also well known for its 70 hectare botanical garden that displays and preserves some of the special Free State flora.

The National Museum dates back to 1877 and has a large collection of fossils and archaeological material, including the famous Florisbad Skull estimated to be 250 000 years old. It also has the only complete skeleton of the semi-bipedal Euskelosaurus, one of the earliest and largest known dinosaurs of approximately 10m long.

Interesting to know:
Part of the Mangaung Municipality, Bloemfontein has over a million citizens. The Sesotho word *Mangaung* means 'the place of the cheetah' and therefore the provincial rugby team, which is based in Bloemfontein, is called the Cheetahs.

The Court of Appeal in Bloemfontein

University of the Free State

Pietermaritzburg

Location: North of Durban on the N3 highway
Significance: Capital of KwaZulu-Natal
Famous for: Associations with world celebrities
The Comrades and the Dusi marathons
Waterfalls and green rolling hills

Famous men like Mahatma Gandhi, Nelson Mandela, Mark Twain, Cecil John Rhodes and Paul Kruger all had some connection with Pietermaritzburg or the Midlands north of the city. As one of the best preserved Victorian cities in the world, with wrought-iron lace-work adorning many of the old buildings, Pietermaritzburg was originally laid out in rectangular blocks according to Dutch town planning custom when the Voortrekkers (early Dutch pioneers who left the Cape Colony) first settled on the gently rising ground between the Dorp Spruit (Town Creek) and the Umsundusi River in 1838.

Within five years, however, the town – named after the two Voortrekker leaders Pieter Retief and Gerrit Maritz – came under British rule and was made the capital of the Colony of Natal. In the Union of South Africa (1910) it was the provincial capital of Natal, and in the new non-racial South African democracy (1994), Pietermaritzburg at first shared provincial capital status with Ulundi in Zululand but it is now once again the only capital of this province. It is a modern bustling city – the gateway to the interior of KwaZulu-Natal and the picturesque Midlands Meander.

Interesting to know:
Pietermaritzburg is the place where the annual Dusi Canoe Marathon starts, and is the start or finish (in alternate years) of the world-renowned Comrades Marathon road race between Durban and Pietermaritzburg.

Pietermaritzburg city hall

Wylie Park

Rickshaw cart in Durban

Durban

Location: On the KwaZulu-Natal coast
Significance: Largest city in KwaZulu-Natal
Busiest container port in Africa
Pleasant sub-tropical, sunny beaches
Economic importance second only to Gauteng
One of the largest aquariums in the world

The area was first called the 'Terra do Natal' by the Portuguese explorer Vasco da Gama when he and his crew sighted land on Christmas Day in 1497. The first settlers were a party of 25 men who settled on a 25 by 100 mile strip of coast granted to them by the Zulu King Shaka in 1824. In 1835, a meeting of 15 residents of Port Natal decided to rename it d'Urban, after Sir Benjamin d'Urban who was then governor of the Cape Colony.

Later, the colonists failed to attract Zulu labourers to work in the newly established sugar plantations, and in the 1860s this led to the importation of thousands of indentured labourers from India on five-year contracts. Many stayed on, and today Durban has the largest Indian community outside India.

The largest city in KwaZulu-Natal, Durban today is a sophisticated, cosmopolitan and fast-growing city of over three million people.

Interesting to know:
In the years before the harbour was established, Durban bay was separated from the sea by a sandbar. The bay was home to hippo and crocodile while huge flocks of flamingoes frequented the shallow waters. Inland, where the suburbs are today, elephant, lion and other wild animals roamed freely until approximately 150 years ago.

uShaka Marine World, Durban

Raw diamond in rock

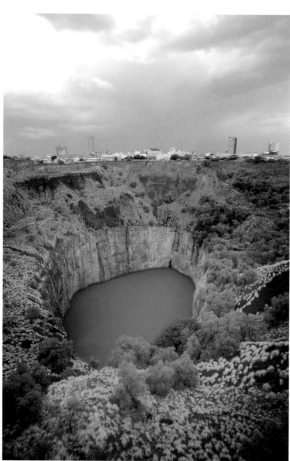

Diamond City

Location: Eastern part of the Northern Cape
Famous for: Diamonds – first diamond rush
 Capital of the province

When Erasmus Jacobs found a large stone on his father's farm on the banks of the Orange River near Hopetown, he thought it was unusual, but worthless. Subsequently, he gave it to their neighbour Schalk van Niekerk. It turned out to be a 21.25-carat gemstone, now known as the Eureka Diamond.

There were diamond rushes, to Hopetown in 1866, and in 1869 to the place that would become the city of Kimberley. By 1871 about 50 000 people from around the world had arrived at this makeshift mining town. Their diggings resulted in a large hole, made almost entirely with picks and home-made tools. After it reached a depth of 18m, the soft soil gave way to harder blue rock which yielded even more diamonds. By this time, the 1 600 people who initially had stakes in the hole were reduced to a small handful of proprietors, including Cecil John Rhodes, Charles Rudd and Barney Barnato, who eventually merged to form De Beers Consolidated Mines. The Big Hole, the largest man-made excavation in the world, is 215m deep and 1.6km in circumference, and is today surrounded by the modern city of Kimberley.

Places of interest:
The McGregor Museum, the Duggan-Cronin Gallery, the Humphreys Art Gallery, the Kimberley Public Library with its collection of Africana books dating back to the diamond rush, the De Beers Mine, and the Big Hole Museum – a reconstructed historical town that features the days of the diamond rush when diggers came streaming to this part of the world to find their fortunes.

The Big Hole, Kimberley

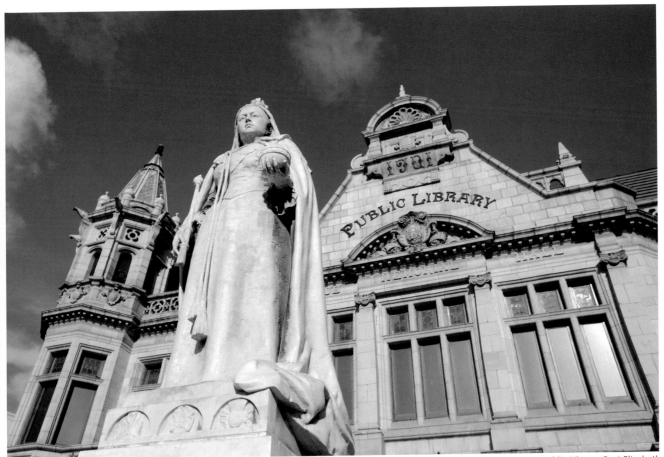

Public Library, Port Elizabeth

Nelson Mandela Bay

Location: In the western part of the Eastern Cape
Significance: One of six metropolitan municipalities in South Africa
Includes Port Elizabeth, Uitenhage and Despatch
The Port Elizabeth and Coega harbours are on the
huge sweep of Algoa Bay

Named after the former South African president, the metro of Nelson
Mandela Bay is the only metropolitan area permitted to bear the great
man's name during his lifetime. Being the centre of the motor manu-
facturing industry in South Africa, the port is an important gateway for
importing large volumes of components. Volkswagen SA is situated in
Uitenhage and the Delta Motor Corporation is in Port Elizabeth.

The first European to reach Algoa Bay was Bartolomeu Dias in 1488.
He planted a cross on one of the islands and named the bay Bahia da
Lagoa. The Portuguese were the first to sail round the southern tip of
Africa in their quest to find a sea-route to the East. The king of Portugal
gave impetus to the voyage by awarding credence to the myth of an
African priest-king, Prester John, whose army would help Christendom
defeat its Muslim enemies in the East during the 1400s. The search for
Prester John was the reason given to religious advisors for the voyages
of discovery around Africa, but their more important mission was to
break into the lucrative spice trade with the East.

Interesting to know:
Behind the Port Elizabeth City Hall is a monument dedicated to the
mythical Prester John (Preste João) and the Portuguese explorers
who pioneered the sea-route round Africa. The large Coptic cross
is believed to be the only one in the world depicting the mythical
Prester John.

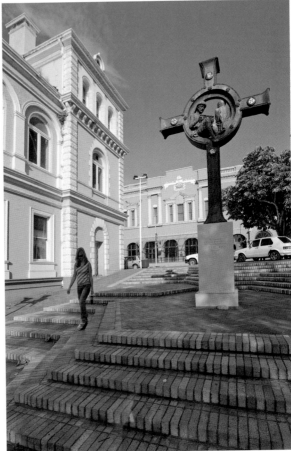

Monument dedicated to Prester John

Cultural Heritage

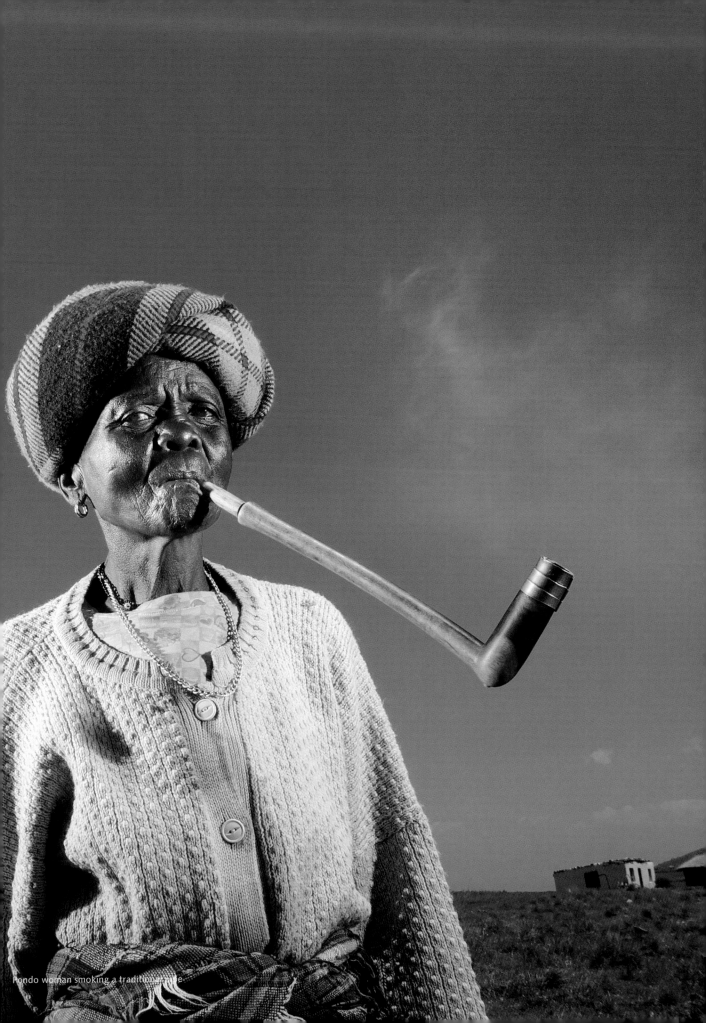

Pondo woman smoking a traditional pipe

Cultural Tourism

Location: Cultural villages, cultural festivals, music performances, heritage routes, museums, art galleries and craft markets

Famous for: Cultural UNESCO World Heritage Sites
Extensive cultural and ethnic diversity

The rich cultural heritage of the diverse South African population is reflected in the large number of excellent museums, art galleries, playhouses and cultural festivals. Both African and western cultures have evolved distinctive South African art forms, music and traditional rituals, incorporating variations and aspects of their ancestral roots.

The annual arts festivals in Grahamstown, Oudtshoorn, Johannesburg, Durban, Cape Town, Potchefstroom and Bloemfontein are some of the largest and most diverse arts gatherings in Africa. South African theatre is internationally acclaimed as being unique and of very high quality, while local music styles have influenced African and world music for decades. Large national orchestras or instrumental ensembles, as well as dance and ballet groups, delight audiences with world-class performances. Art galleries showcase indigenous, contemporary and historical works, and crafts markets are a growing industry, especially in the informal sector. Museums ensure the preservation of artefacts and collections that are important to all South Africans.

Interesting to know:

Four of South Africa's first eight UNESCO World Heritage Sites are cultural sites, while one is a mixed cultural/natural site. The five are: Robben Island, the Cradle of Humankind, the Mapungubwe Cultural Landscape, the Richtersveld Cultural and Botanical Landscape, and the uKhahlamba-Drakensberg Park.

Craft markets are popular attractions

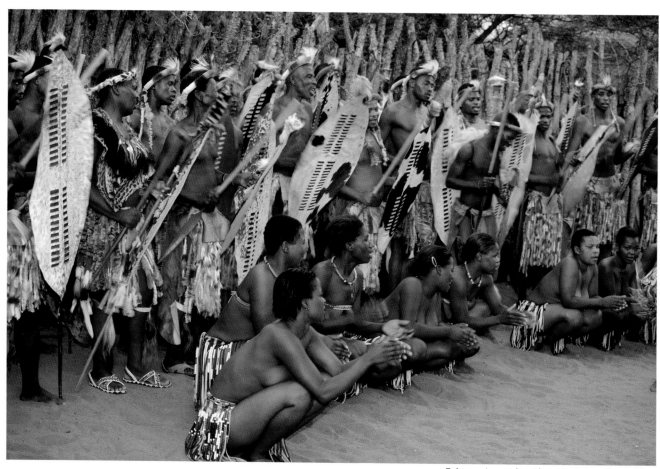

Zulu warriors and maidens at a Zulu cultural village

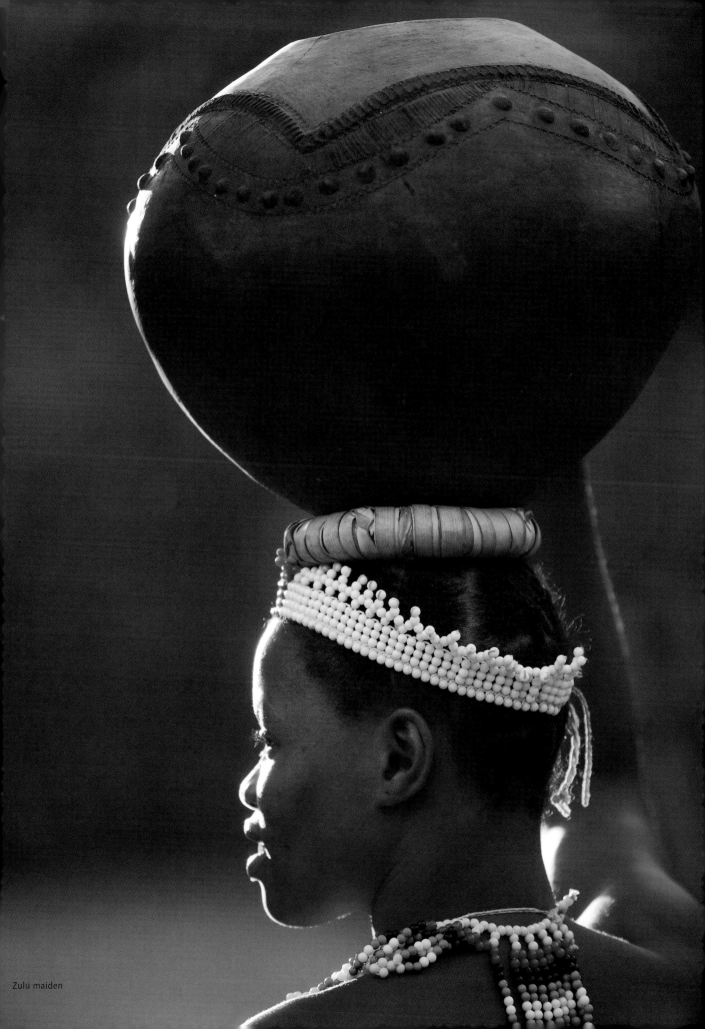

Zulu maiden

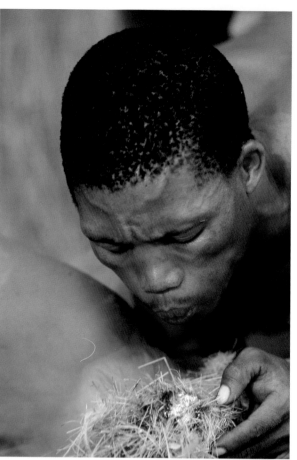

Ancient San

Location: Mainly in the Kalahari area of the Northern Cape and Botswana

Significance: A tribe of people indigenous to southern Africa
Also known as Bushmen, Sho, Basarwa, !Kung, Khwe

The San culture includes a kinship system characterised by a society of small, interdependent nomadic groups. Traditionally an egalitarian people, the San have hereditary chiefs but make decisions as a group, with men and women relatively equal in status. San children are brought up to be well-behaved, and not segregated by gender. Boys and girls are not raised to be either dominant or submissive and are treated kindly by parents. The economic system in San society used to be based on a gift economy – instead of trading goods, they gave one another gifts on a regular basis.

Known for surviving in some of the most inhospitable environments, the San have an accumulated knowledge of how to live off the land while at the same time not depleting its resources. Their respect for the earth and its creatures is seen in their ritualised hunting, and in a spiritual, even mystical, connection with their quarry. Originally hunter-gatherers, these peaceful people have left behind numerous examples of their traditional rock art over thousands of years.

Interesting to know:

The San are genetically one of the oldest peoples in the world. They occupied large parts of southern Africa (including Namibia, Botswana, Zimbabwe and South Africa), but were displaced by the Bantu tribes moving down from central Africa and by European settlers. Today the surviving San occupy only small parts of southern Africa.

San kindling a fire

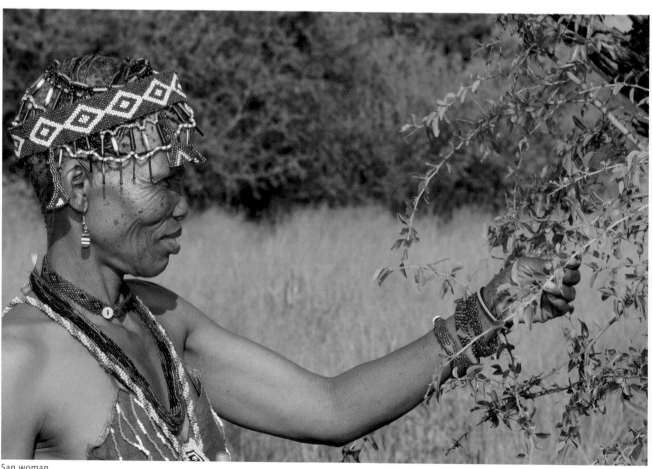

San woman

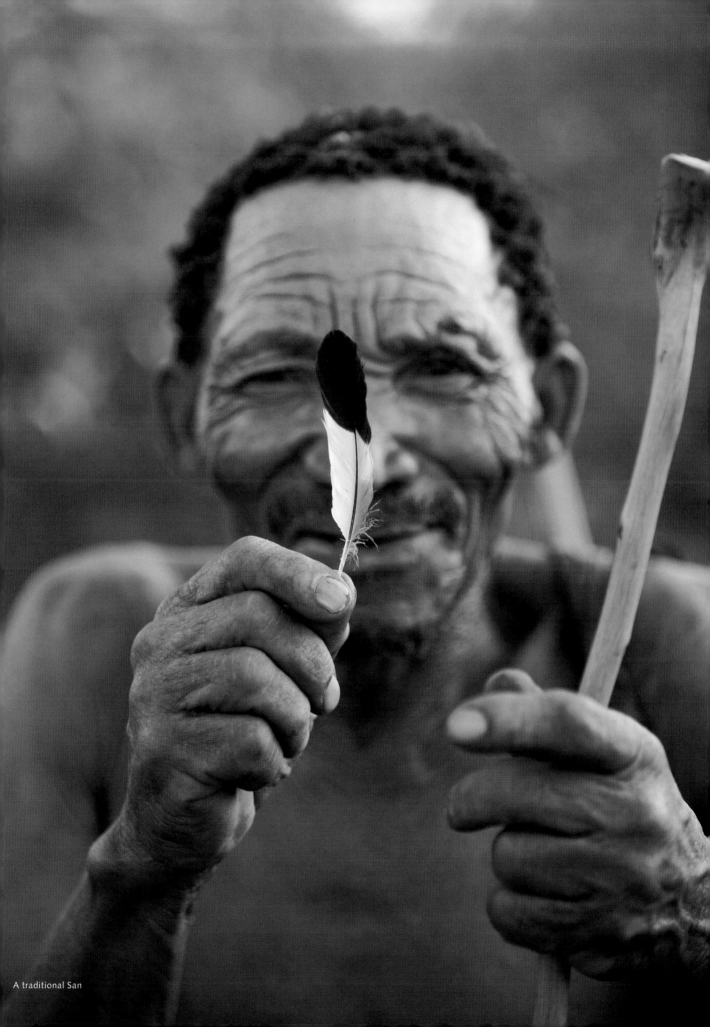

A traditional San

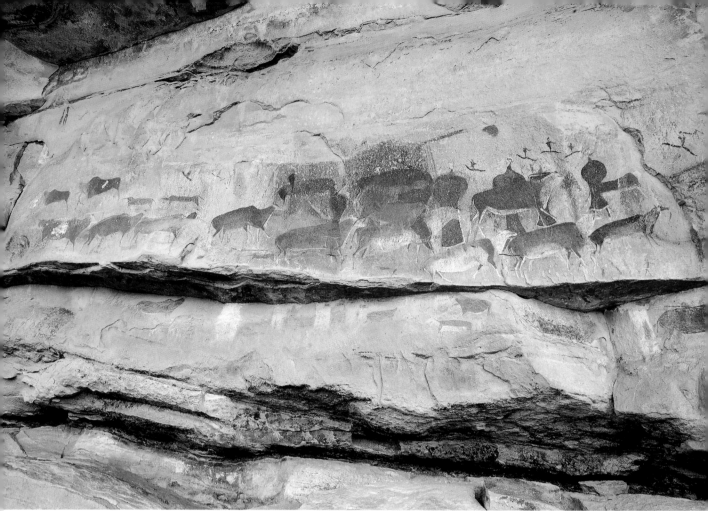

San art at Kamberg in the Drakensberg

Dream Art

Location: Caves in the uKhahlamba-Drakensberg
Significance: Ancient art by San, Late Stone Age people
Hunter-gatherers' cave shelters
Rock paintings depicting San way of life

The San people occupied the uKhahlamba-Drakensberg area for more than 8 000 years, and left the richest collection and concentration of rock paintings in sub-Saharan Africa. Outstanding both in quality and diversity of subject, the oldest date back about 2 400 years. The artists used a shaded polychrome technique in which two colours, usually white and red, were delicately shaded into each other.

Much of the San rock art reflects the importance of their mythology and belief in the shaman – one of their people with special powers to reach the spirits, to heal and make rain, see where the eland are and guide antelope towards hunters crouched in ambush. The shaman would enter into a trance either during a communal ritual or in a more solitary situation. The paintings reflect man and beast in an astonishing range of positions.

There are approximately 15 000 known rock art sites in South Africa, the best of which – about 600 sites, with 40 000 images – can be seen in the uKhahlamba-Drakensberg.

Interesting to know:

Ezemvelo KZN Wildlife has developed the Didima camp to pay special tribute to the San people and their art. The camp has a San Rock Art Interpretive Centre, which provides fascinating insights into the art and culture of the San, and includes static displays and audio-visual presentations in a reconstructed rock shelter.

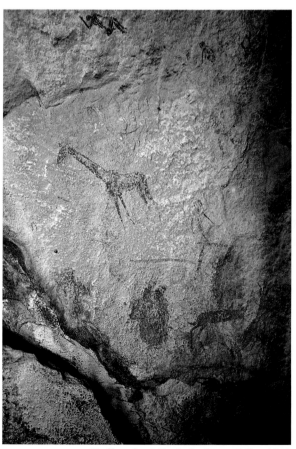

Giraffe rock painting in the Kruger National Park

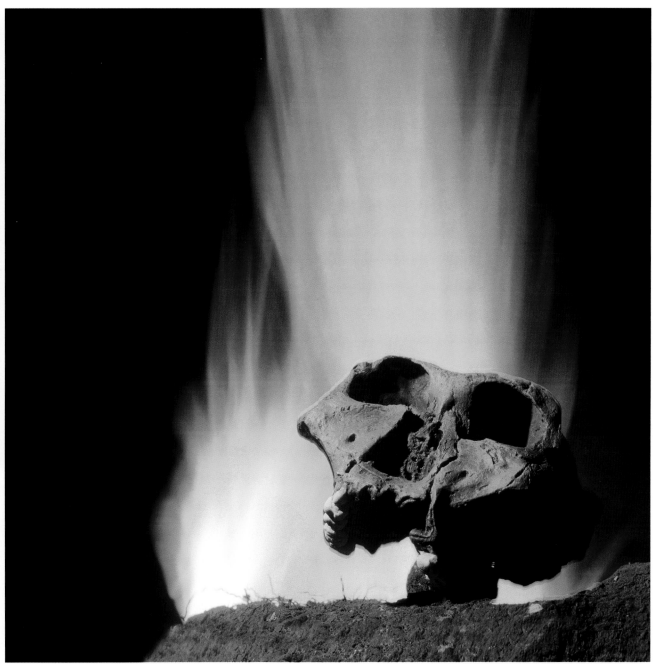

A copy of a fossilised hominid skull found at Sterkfontein

Cradle of Humankind

Location: Shared between Gauteng and North West provinces
Covers 47 000ha of mostly privately-owned land

Significance: Comprises a series of a dozen dolomitic limestone
caves with hominid fossilised remains
A UNESCO World Heritage Site

The dolomite in which the caves formed started out as coral reefs growing in a warm shallow sea approximately 2.3 billion years ago. Over millennia the sea receded and the corals were transformed first into limestone and then into dolomite. Gradually acidic groundwater started dissolving the calcium carbonate and underground caverns were formed. As the water table receded and erosion took place, the caverns were exposed to air, shafts formed between the different cav-

erns and eventually bones, stones and plants were washed down into them. Even animals and hominids (early humans) fell into some of these caves, were trapped, died and eventually became buried in breccia, and fossilised.

The scientific value of this area lies in the fact that these sites provide us with a window into the remote past and help us understand how early ancestors of man developed and changed. At least seven of the 12 sites have to date yielded over 850 hominid remains, making this one of the world's richest concentrations of these valuable finds.

Interesting to know:
The Sterkfontein Caves are located in the Isaac Edwin Stegmann Reserve about 10km from Krugersdorp. The caves were donated to the University of the Witwatersrand by the Stegmann family. A section of the caves is open to the public, and there is a gravel platform from which the excavations can be viewed.

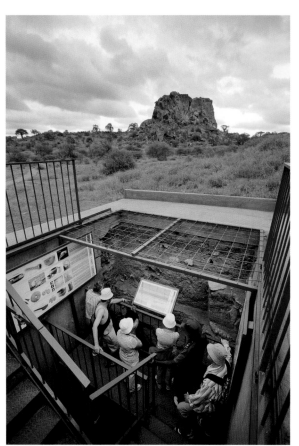

Excavations at the World Heritage Site

Mapungubwe

Location: Near the confluence of the Shashe and Limpopo rivers, in the northern part of Limpopo where three countries meet

Significance: South Africa's fifth World Heritage Site, it has the largest archaeological collection of gold artefacts in Sub-Saharan Africa

The Iron Age population living in the region prospered from 1050 to 1270 AD. Mapungubwe Hill was inhabited for about 70 years, from 1200 to 1270 AD, forming a society far more advanced than other regional civilisations at the time. The hill, consisting of sandstone with sheer cliffs and a flat top, is now a UNESCO World Heritage Site for its cultural importance. It is also where a prize exhibit was found – the gold-covered carving of a rhino some 12cm long and 6cm high.

The people who lived here are considered significant because of the apparent complexity of their society. Many archaeologists believe that it was the first class-based culture in southern Africa. It is thought the people of Mapungubwe traded with distant countries such as Egypt, India and China, and that agriculture flourished which added to their wealth and allowed their population to grow to approximately 5 000.

Interesting to know:

Mapungubwe's society did not survive over time. Its remains were discovered in 1933 by a local farmer. Archaeologists continue to investigate the sites of the palaces, a settlement area, and two earlier capital sites. Related sites are the Mmamagwe Ruins in Botswana and Great Zimbabwe Ruins in Zimbabwe.

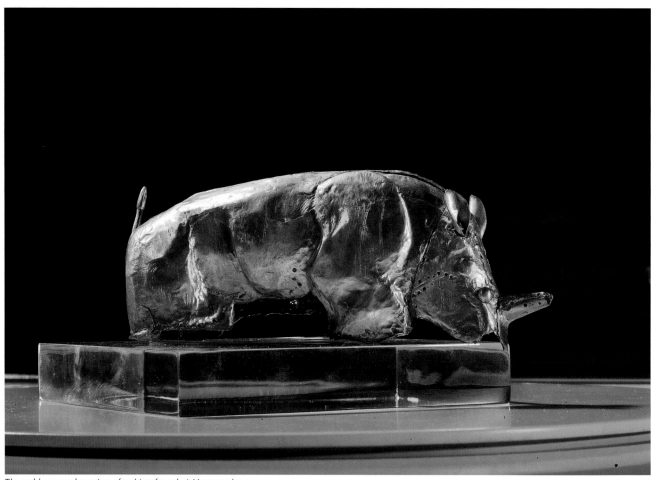

The gold-covered carving of a rhino found at Mapungubwe

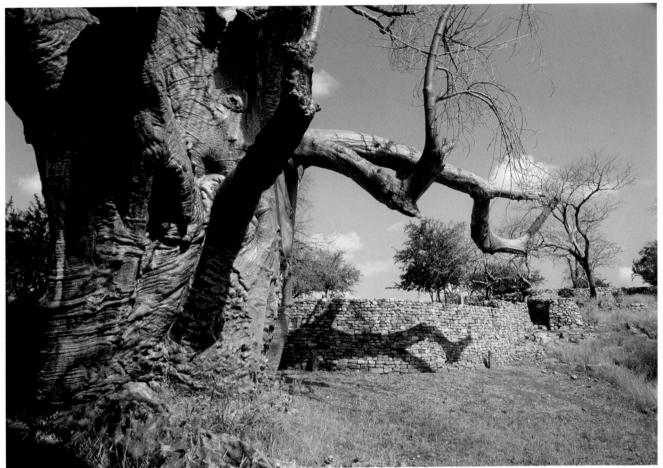
An ancient Baobab guards the ruins of Thulamela

Thulamela

Location: The Pafuri area of the Kruger National Park
Significance: Bantu-speaking Nguni people lived here
It was the capital of an iron-age kingdom, probably allied to Mapungubwe and formerly to Great Zimbabwe. The kingdom flourished from 1250 to 1700 AD

The people of Thulamela were known for mining iron ore – they had up to 200 mines – and they traded their gold, iron and ivory with people from what is now Mozambique, for beads, cloth, ceramics and corn. Chinese porcelain, glass beads, jewellery and an array of evidence of their civilisation, including a network of buildings, was found in 1991 by a park ranger.

The central part of Thulamela, the royal enclosure, housed up to 1 000 people, including the royal family. Beyond that, hundreds of dwellings covered the hillsides. To this day many of the walls remain, indicating that a further 2 000 people may have inhabited the area. The tombs of an African king and queen, believed to have ruled over Thulamela in the 1500s, were recently excavated. The queen was buried facing the king's chamber and their bodies were ornamented with gold, indicating their royal status. Soon after the death of these royals the kingdom came to an end.

Interesting to know:
There is evidence that the rulers of Thulamela controlled a trade network between Mozambique and what is today the South African interior, and that they possibly also traded with people from West Africa.

A reconstructed royal chamber

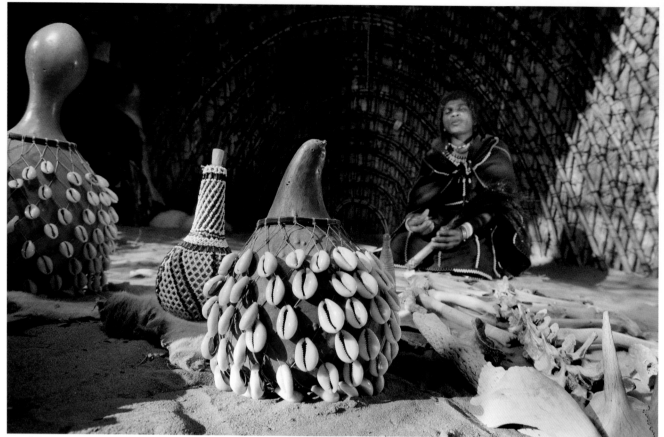

A traditional healer – locally known as an *isangoma*

A married woman wearing a traditional headdress

People of Heaven

Location: Zululand in KwaZulu-Natal is the Zulus traditional home, but they are spread over the entire country with many now living in Gauteng

Significance: Zulus are the largest ethnic group in the country numbering 10–11 million

The word *izulu* means sky, heaven or weather, and so *amaZulu* can be taken to mean 'people of heaven'. The Zulu clan was founded in 1709 by Zulu kaNtombela, who was Nguni in origin. Different tribes lived in peace and far apart but when famine struck the area, they started raiding each other for cattle and food. The chief Dingiswayo and his tribe were particularly feared for their successful raids. Shaka served in his army and there he learned many clever and useful tactics of warfare. In due course he himself became an unrivalled military leader.

After the murder of Dingiswayo and his direct successors in 1818, Shaka became king of the Zulu nation. He united different tribes and gradually built a powerful Zulu Empire with a fighting force of 20 000 warriors. In 1824, soon after he became king, Shaka gave permission for a small group of British people to settle at Port Natal (later called Durban). Years later, after conflict with the Voortrekkers and after Natal became a British colony, the Zulus refused to submit to British rule. Under their king Cetshwayo, they trounced the British in the battle of Isandlwana in 1879, but after the battles of Rorke's Drift and Ulundi, the Zulu people were defeated.

Interesting to know:
The amaZulu are a proud nation with the Zulu kingdom's capital still situated at Ulundi in the heartland of KwaZulu-Natal. Their traditional staple diet consists of beef, cereal foods including *puthu* (cooked maize meal) and *amasi* (curdled milk).

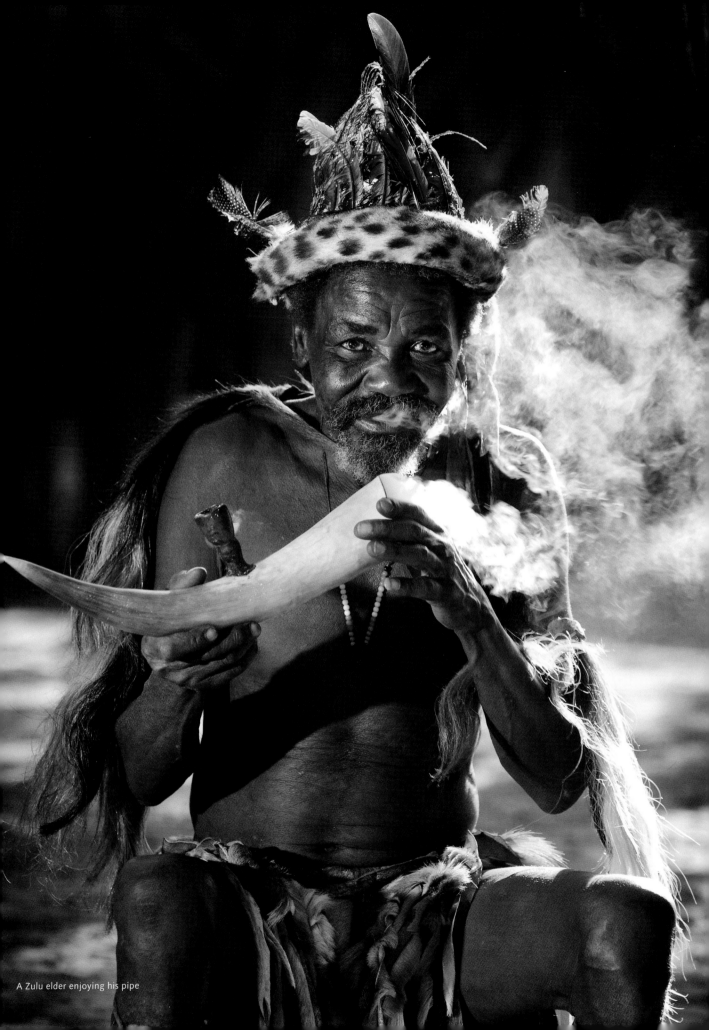

A Zulu elder enjoying his pipe

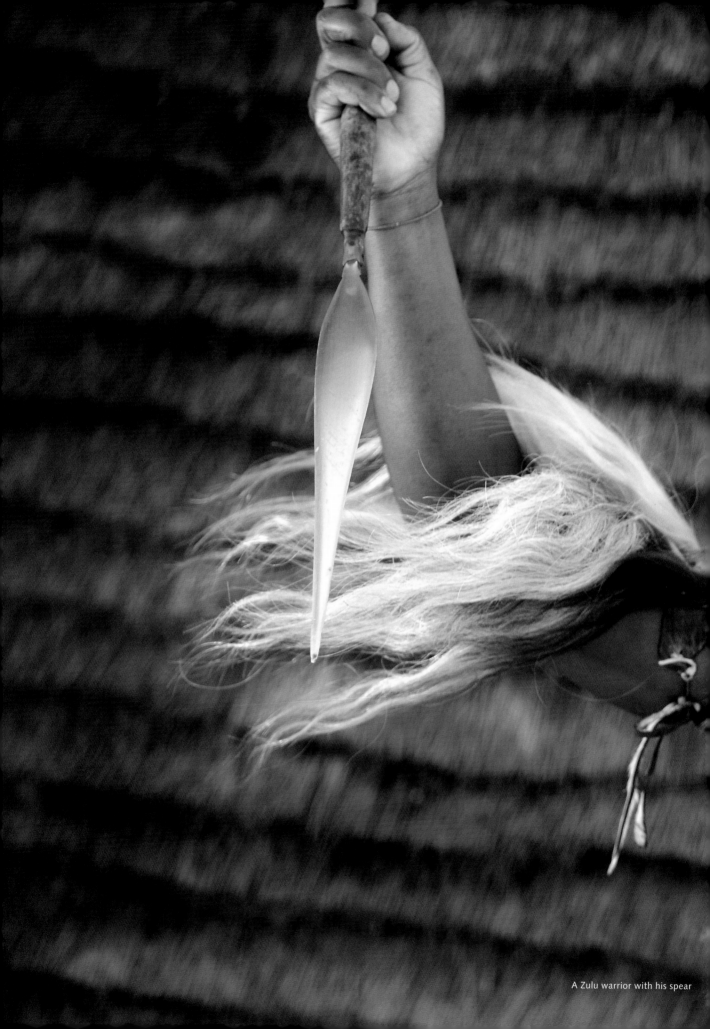

A Zulu warrior with his spear

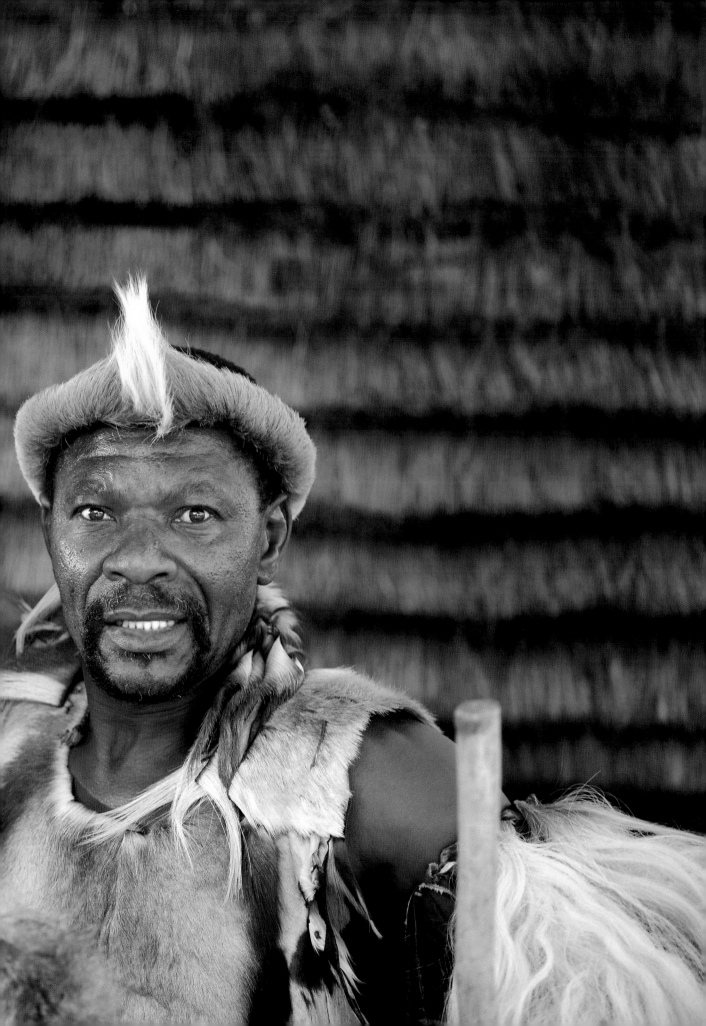

A typical Xhosa home

A family dwelling

People of the Wild Coast

Location: The traditional home of the Xhosa is the Transkei and Ciskei north of the Fish River, but Xhosas also live in many other parts of South Africa
Also called: amaXhosa or Xhosa people
Significance: The second-largest cultural group in the country

Deriving their name from the legendary leader uXhosa, the majority of the Xhosa people in South Africa live in the Eastern Cape. Their language, isiXhosa, has 15 click sounds, and has many features borrowed from the language of the Khoisan (the aboriginal inhabitants of South Africa). The former president of South Africa, Nelson Mandela, is a Xhosa by birth.

The Xhosa traditional culture includes diviners, *amagqhira*, who are mostly women and who act as herbalists, prophets and healers. The culture has a strong oral tradition, which includes stories of ancestral heroes. A characteristic figure in Xhosa cultural society is the praise singer or *imbongi*, who historically lives close to the chief and accompanies him on important occasions. Present-day imbongi Zolani Mkiva preceded Nelson Mandela at his presidential inauguration in 1994. Other cultural institutions that survive to this day include the coming-of-age Manhood Ritual, *Ulwaluko*, and the Womanhood Initiation, the *Intonjane*.

Interesting to know:
One custom in the Xhosa culture is the smoking of pipes by both men and women. Young women are allowed to smoke shorter pipes, but longer pipes are the privilege reserved for mature women who have borne children. The length of the pipe was originally to prevent ash falling on pregnant bellies or on babies on laps.

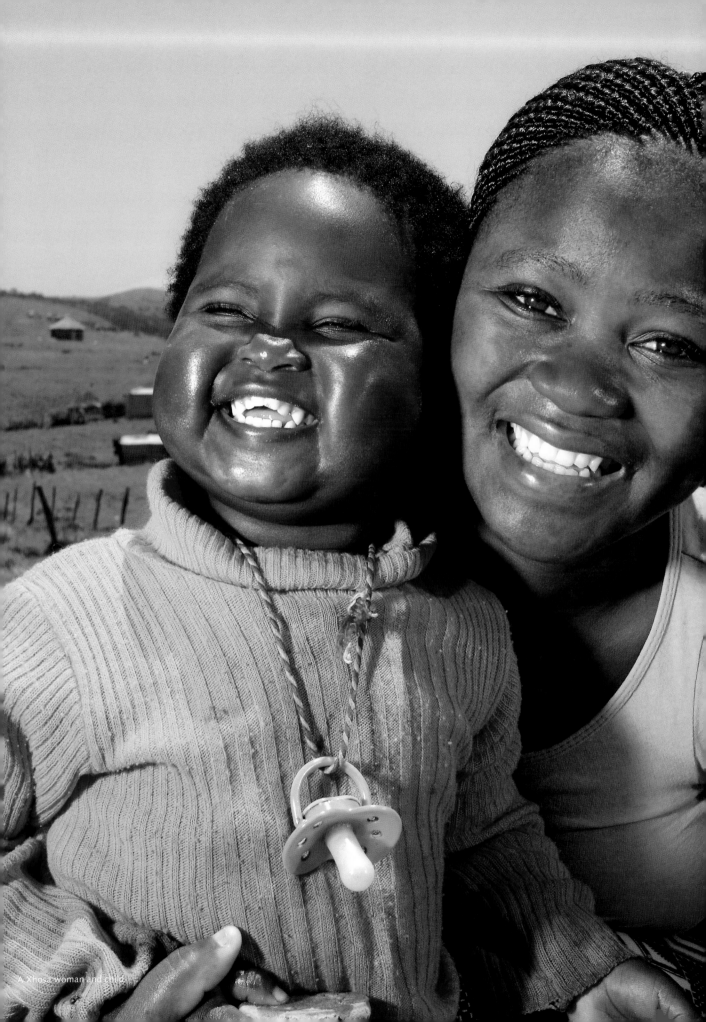

A Xhosa woman and child

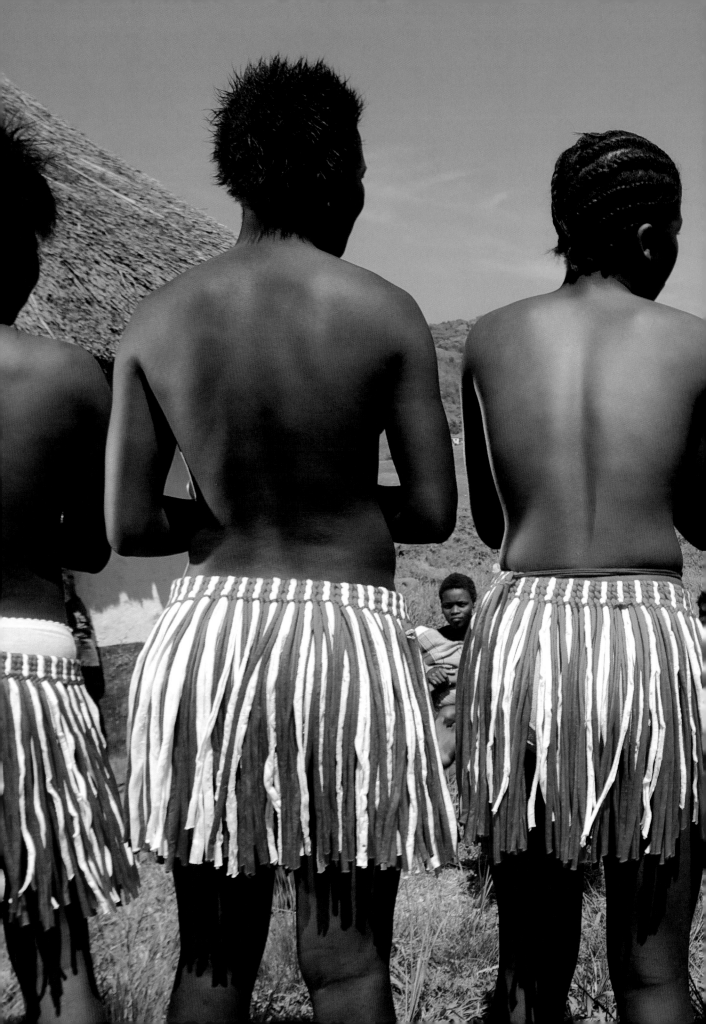

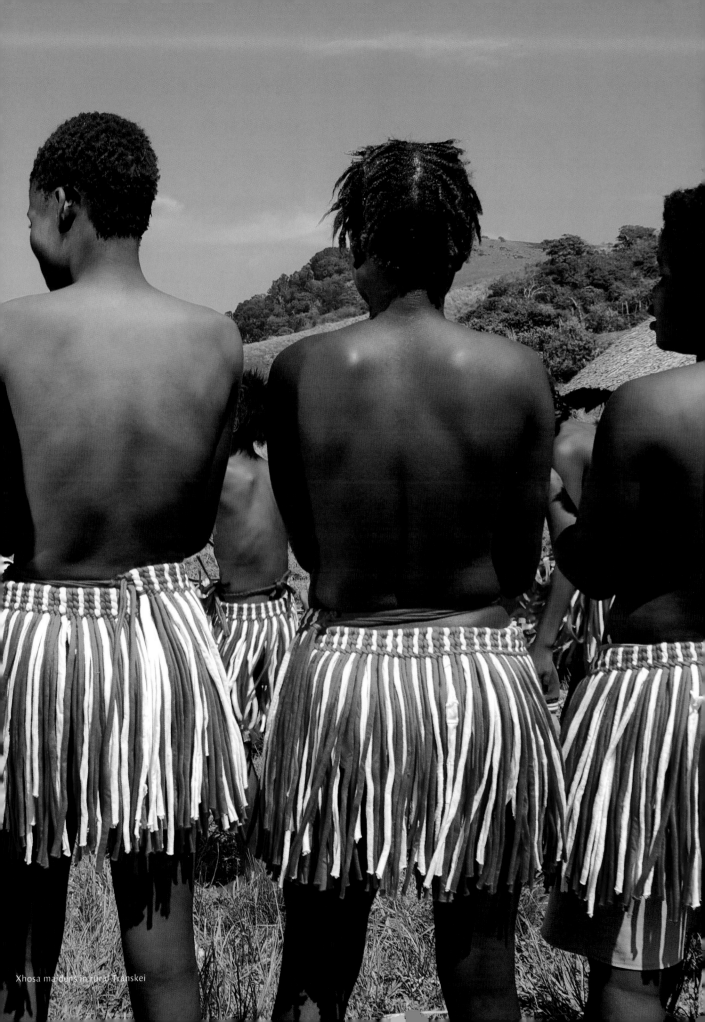

Xhosa maidens in rural Transkei

A Sotho man with his typical cone-shaped hat

People of the Highlands

Also known as: Sotho or Basotho
Where they live: All over South Africa, but are concentrated in Lesotho and in the northern half of the Free State
Significance: They are a Bantu tribe with a history of iron smelting and ivory- and wood-carving

The early history of the Sotho is unknown, but evidence of Sotho settlement in Phalaborwa in the eighth century AD and Melville Koppies in present-day Johannesburg in the 11th century, including traces of their iron-work, has been found. It was also the Sotho who inhabited Mapungubwe in the 12th century, and who traded with China long before Europeans arrived in that part of South-East Africa. It is also believed the traditional conical Sotho hat is linked to this eastern connection.
As a Bantu tribe, the Sotho have marked differences to the Nguni, Venda and Tsonga groups, particularly in language and social customs. The Sotho group their homesteads in villages (small communities) instead of kraals (huts surrounded by a stockade) as the Ngunis do. Each village has a paramount chief, and a hereditary regional chief rules all villages. Their marriage customs differ from those of Nguni tribes in that a man will often choose a wife from a group to whom he is already related or considered kin.

Interesting to know:

Sotho rituals are believed to reflect hunting relationships and therefore each Sotho group is associated with a wild animal. For example, the Kwena group recognised the crocodile; the Pedi associated themselves with the porcupine; the Phiri with the hyena; and the Tlokwa with the wild cat.

Sotho homestead

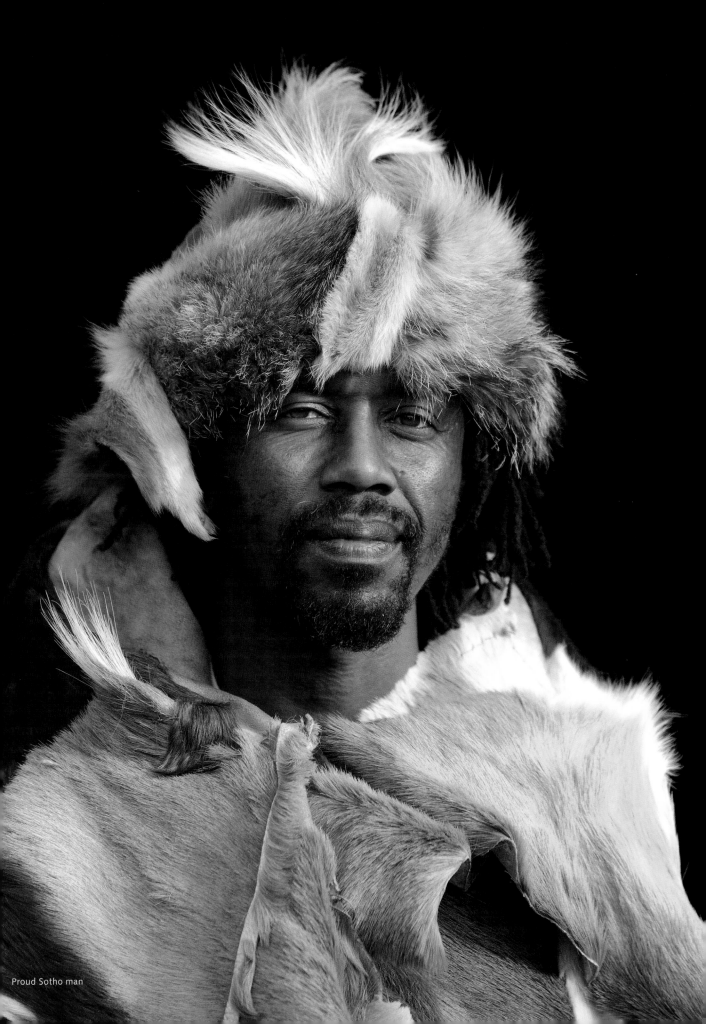

Proud Sotho man

Ndebele People

Also known as: AmaNdebele
Who they are: An Nguni tribe, descended from people who migrated southward in the 17th century
Known for: Colourful house-decoration and beadwork

In the 1600s, a large group of Nguni-speaking people were living in the eastern coastal part of the country, and from them a group broke away and migrated to what is today Limpopo and Mpumalanga. They formed the Ndebele tribe and developed, as part of their culture, a style of elaborate beadwork and painted house-decorating patterns that has made them immediately recognisable.

Much of the history of the Ndebele is unknown, but in the 1800s they were in conflict with the Voortrekkers near what is now Tswane. Along with a proud tradition of warriors, the Ndebele's cultural identity is associated with their beadcrafts and painting. Their style of house decorating has been practiced for over a hundred years, and it is believed the earlier designs painted on to their walls were created at their ancestors' wishes, and were thought to have sacred powers. The painting and beading is traditionally done by women, usually in the late autumn and winter once the harvesting is completed, and these activities form part of the Ndebele women's domestic tasks. Motifs of their beadwork show great artistic vitality.

Interesting to know:
As the tribe has come into contact with western society, it has adapted and made use of new elements in its designs. However, much of its tradition is fervently maintained, such as the use of the fingers to paint on to walls, and the typical style of the designs.

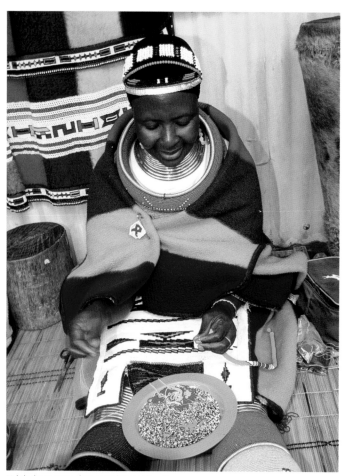

Ndebele woman doing traditional beading

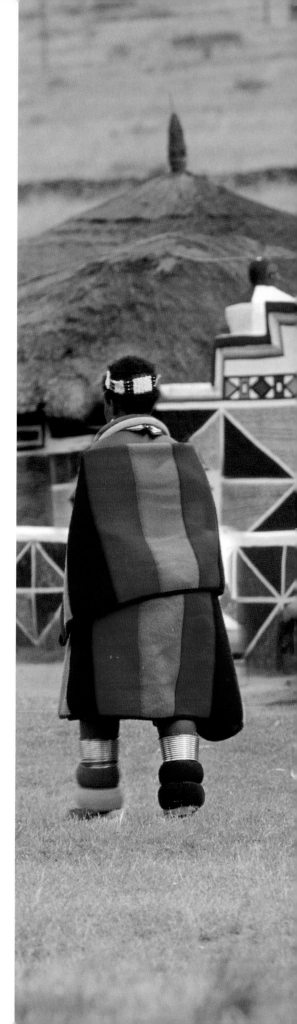

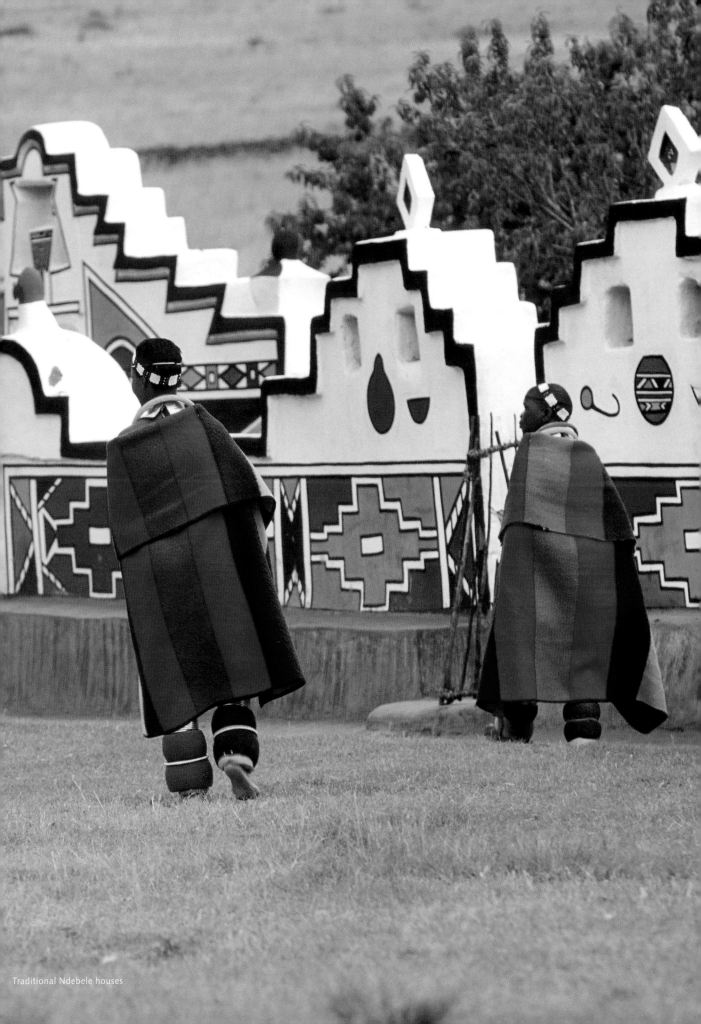

Traditional Ndebele houses

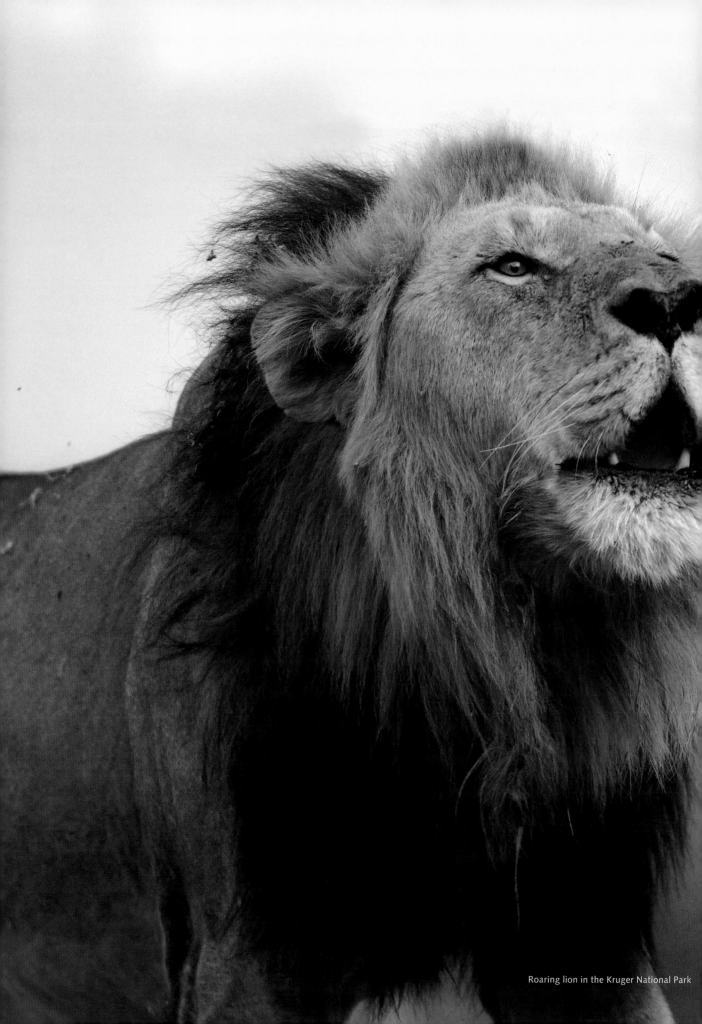

Roaring lion in the Kruger National Park

Natural Heritage

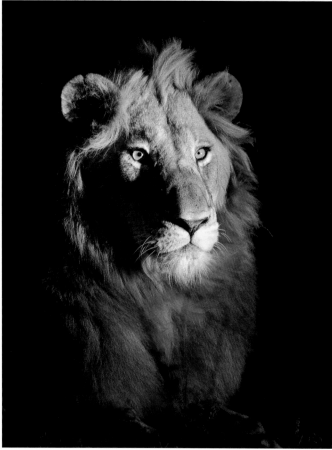

Lion

The Big Five

Occurrence: Most large national parks and game reserves
Origin of naming: Designated by hunters
 Top five hunting trophies

In Africa, a few of the most formidable and fiercest animals have entrenched their place in the human psyche – the lion with its power and hunting skills; the leopard with its beautiful coat; the unpredictable buffalo; the temperamental rhino; and the largest land animal, the elephant.

Although these five species are not the only ones that are rare, interesting, large, powerful or dangerous, they have captured man's imagination and both trophy hunters and nature lovers refer to them as the Big Five. Since they require extensive space, they are mainly confined to large national parks and game reserves. To encounter any of the Big Five on a game drive is the aspiration of many, but to find all of them on a single drive is a rare privilege.

Interesting to know:
The new Greater Addo National Park, known for its elephants, includes a marine area as far as Bird Island and beyond. Apart from the Big Five on land, one can also encounter the Big Two in the marine area, making this the only national park that offers the Big Seven.

Great white shark

Southern right whale

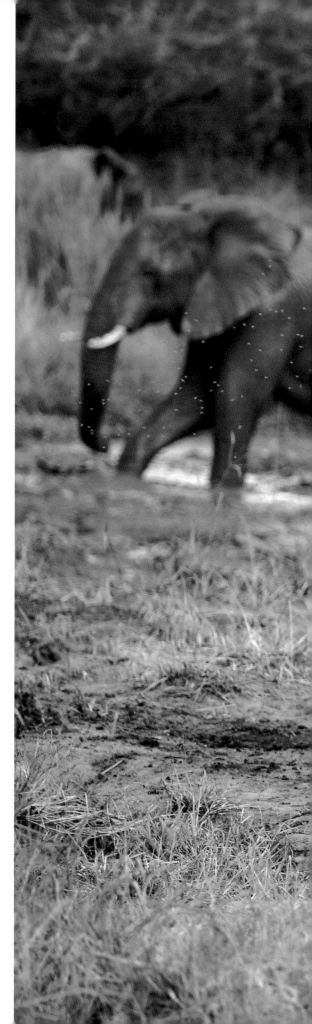

70

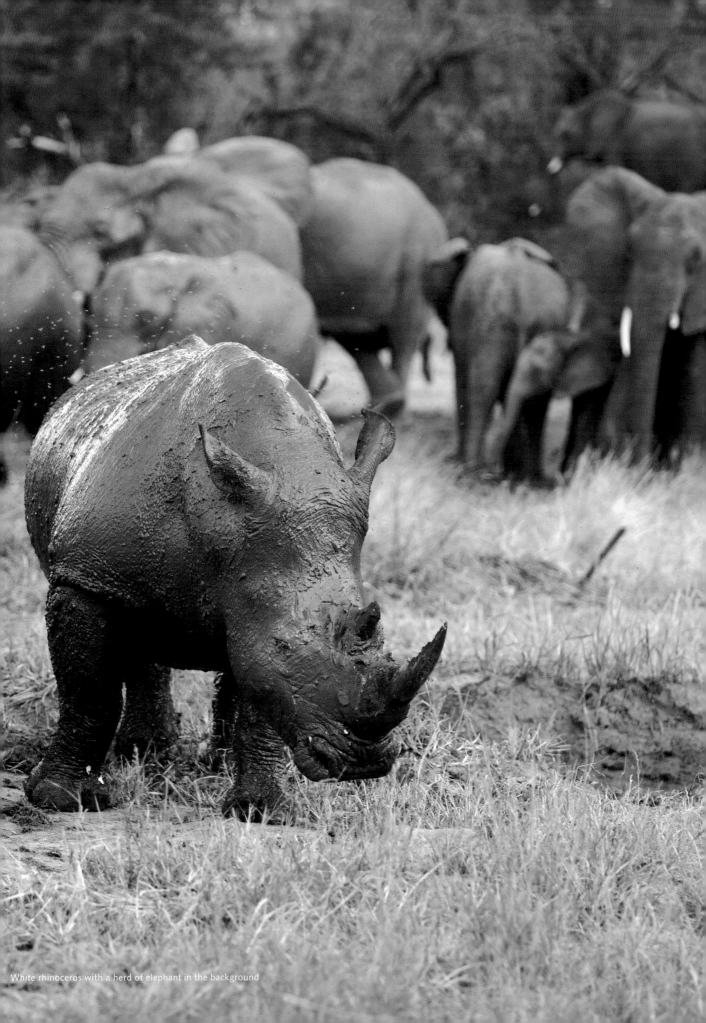

White rhinoceros with a herd of elephant in the background

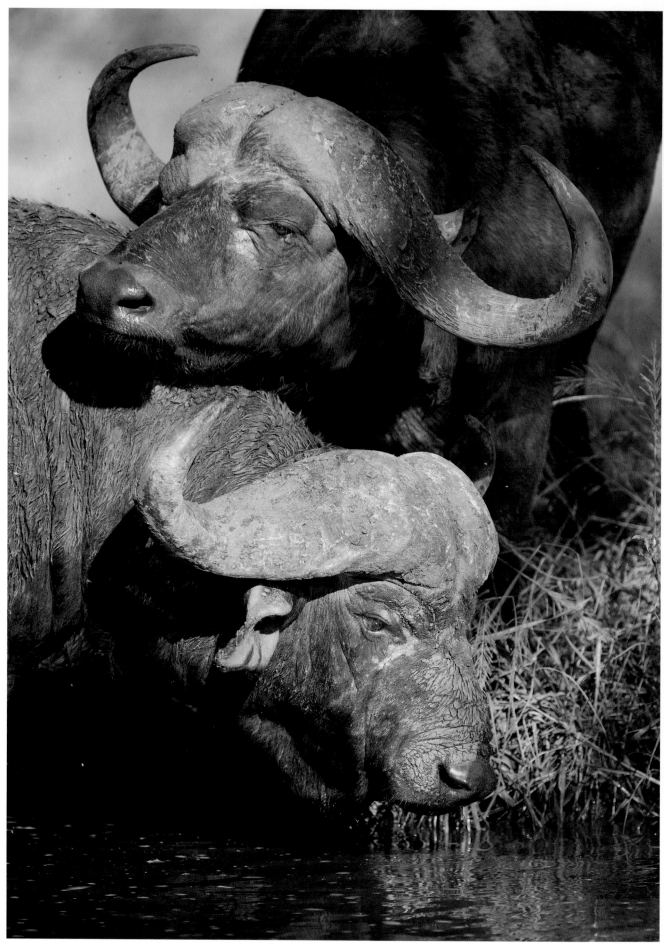

African buffalo

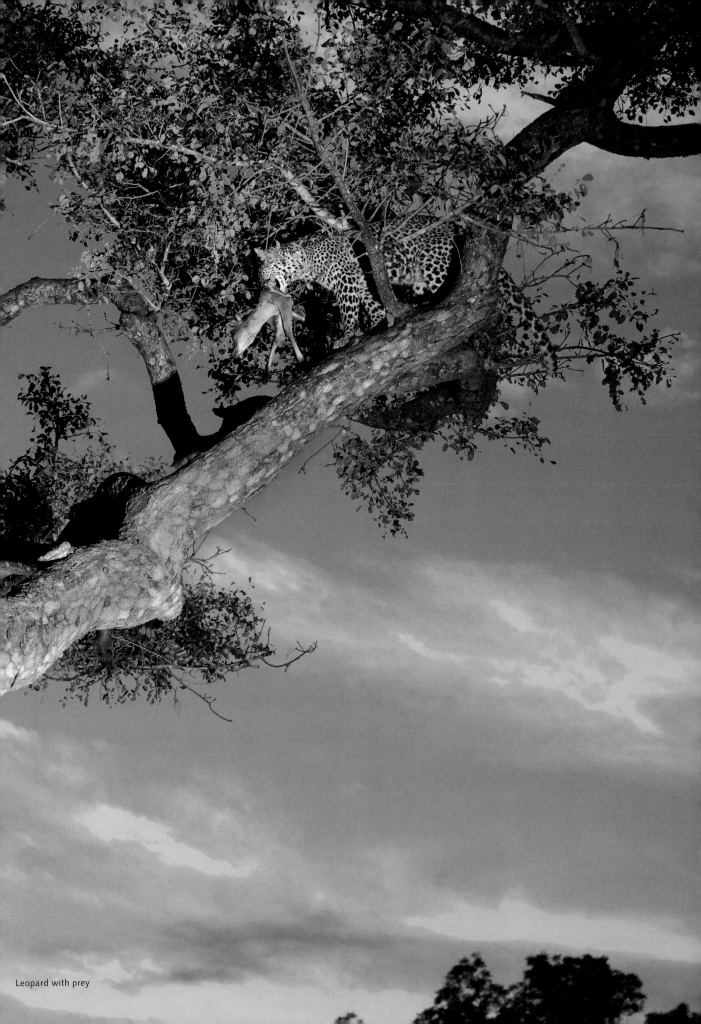

Leopard with prey

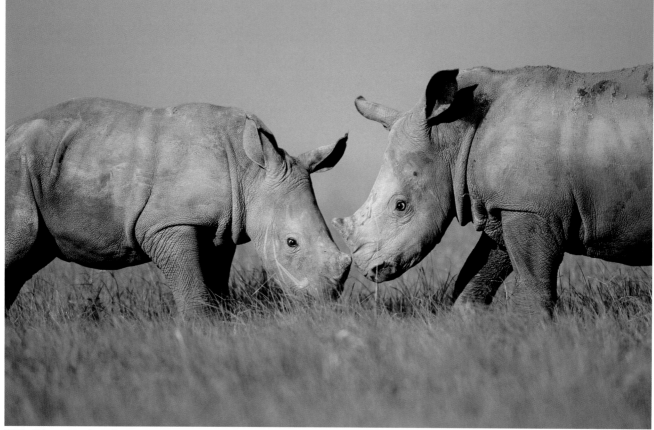

White Rhinoceros calves playing

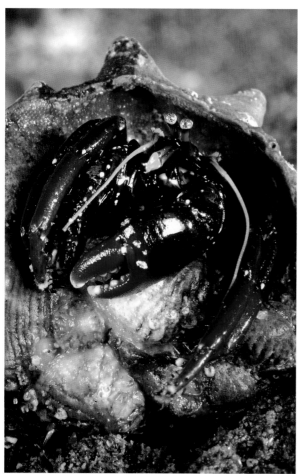

Hermit crab

iSimangaliso

Location: Stretches from Cape St Lucia to Kosi Bay estuary and inland to Umkhuze

Significance: The iSimangaliso Wetland Park is the first South African World Heritage Site Recognised by UNESCO in 1999 to protect the variety of ecosystems and landforms in the area Tourism brings tangible benefits to the Tsonga and Zulu communities adjacent to the park

The word *iSimangaliso* is the Zulu for 'a marvel, a wonderful thing'. The iSimangaliso Wetland Park is being developed as a single open ecological area where animals can follow their historic migratory paths from the Lebombo Mountains in uMkhuze to the coastal plains of the Indian Ocean. The 332 000 hectare park contains three major lake systems, eight interlinking ecosytems, most of the remaining swamp forests in South Africa, Africa's largest estuarine system, 526 bird species and 25 000-year-old coastal dunes. The fishing methods used by the local people have not changed in 700 years.

This park provides marine, wetland and savannah habitats, and the continuing evolution of animal and plant species strengthens its biodiversity.

Interesting to know:

The iSimangaliso Wetland Park is home to the endangered palm-nut vulture; the tallest land mammal, the giraffe; the endangered two rhinoceros species; the largest land mammal, the elephant; the largest marine mammal, the whale; the largest marine reptile, the leatherback turtle; the largest fish, the whale shark and the most ancient 'living fossil', the coelacanth.

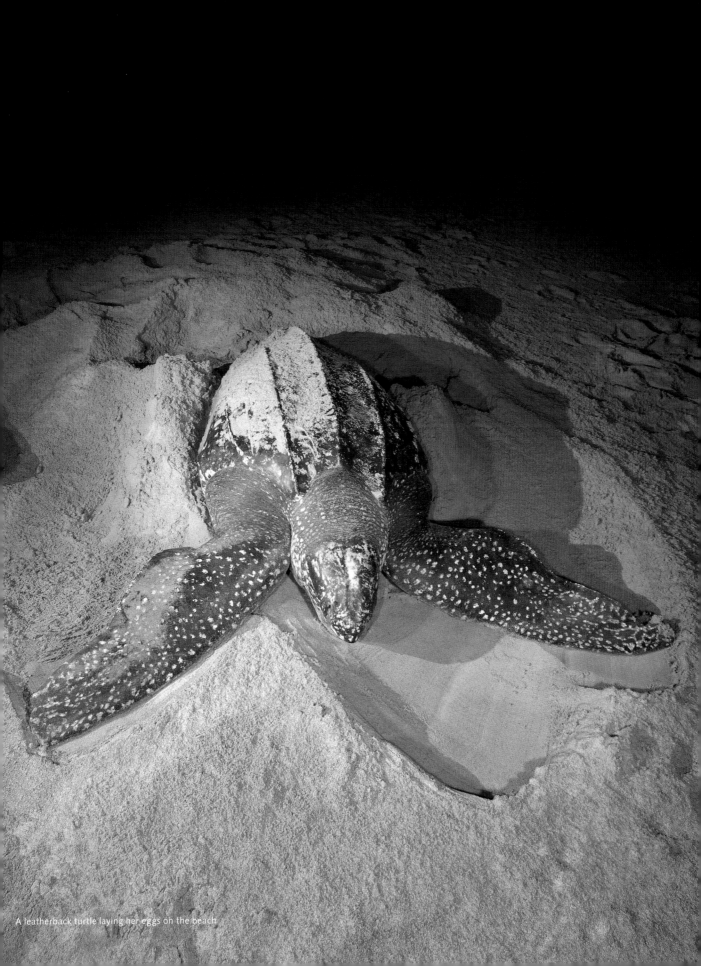
A leatherback turtle laying her eggs on the beach

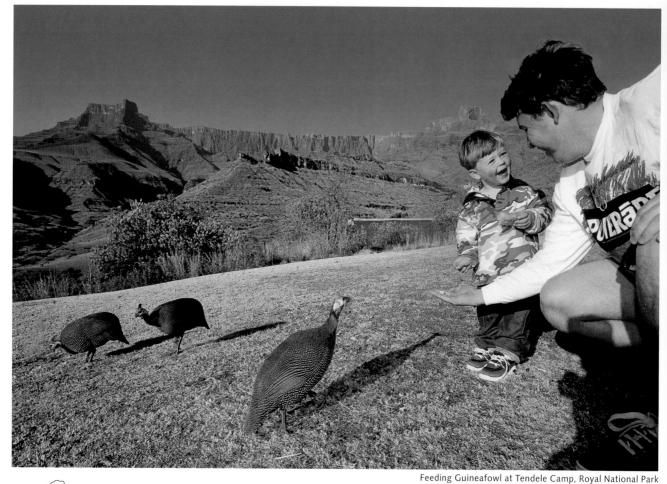

Feeding Guineafowl at Tendele Camp, Royal National Park

uKhahlamba-Drakensberg

Location: On the border between Lesotho and KwaZulu-Natal
Significance: Part of the elite list of mixed World Heritage Sites
Natural and cultural richness and diversity

The Zulu word *uKhahlamba* means a barrier of spears and the Afrikaans word *Drakensberg* means mountains of the dragon. In 2000, this 24 300 hectare paradise of cliffs, valleys and rivers was declared one of only 23 World Heritage Sites.

The largest section of the park is pristine wilderness and access is only on foot. There are no roads, and most areas are free of any signs of human impact. In summer, the mountainsides are covered with breathtaking floral fields. For most of the year, summit temperatures range from very cold at night to hot or very hot at midday. Ice and snow frequently wrap the baldness of the peaks for months at a time. High summer is humid, short but intense.

The lower slopes and valleys are mainly covered by temperate grassland. The climate here is mild and pleasant. Protea are found on the northern slopes and yellowwood forests occur in the sheltered river valleys and on the southern slopes where it is cooler. The sandstone layers are the limit of the tree line and no trees except woody shrubs occur above that.

High rainfall combined with snowfalls and the porous basalt rocks result in the Drakensberg being the most important water catchment area in South Africa.

Interesting to know:
The total number of plant species recorded represents approximately a tenth of all the plant species found in South Africa and about 13% of these are endemic.

A major water catchment area

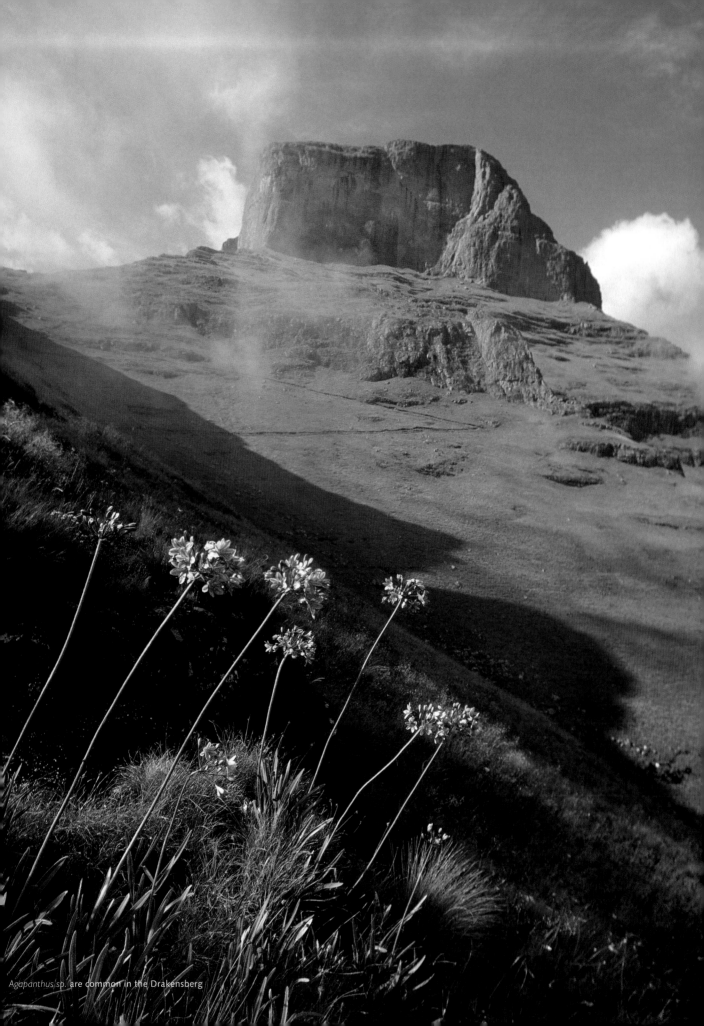

Agapanthus sp. are common in the Drakensberg

Kruger National Park

Location: Eastern lowveld of Mpumalanga and Limpopo
Famous as: The largest national park in South Africa, one of the flagship destinations of South Africa, and part of the Greater Limpopo Transfrontier Park

The main mission of the park and its predecessors, to conserve the lowveld fauna and flora, has remained constant for more than a century. The park has become an international leader in environmental management and conservation. It was named after Paul Kruger, fifth president of the South African Republic from 1883 to 1900, who created the Sabi Game reserve in 1898 (located in the southern third of today's park). In 1903, Shingwedzi Reserve was proclaimed (in the northern part of the modern park) and 23 years later the two reserves as well as adjacent farms were combined to form the Kruger National Park. It opened to the public in 1927.

The Kruger National Park is two million hectares in extent, 350km from north to south and 60km east to west. It is flanked by Mpumalanga and Limpopo provinces to the west, Mozambique to the east and Zimbabwe to the north. It forms part of the Greater Limpopo Transfrontier Park, a peace park established in 2002, which includes Mozambique's Limpopo National Park and Zimbabwe's Gonarezhou National Park. The park is also part of the Kruger to Canyons Biosphere, selected as an International Man & Biosphere Reserve.

Interesting to know:

The present-day Kruger National Park encompasses six ecosystems and is home to 517 species of birds, 147 species of mammals, 336 types of trees, 49 species of fish, 34 species of amphibians and 114 species of reptiles.

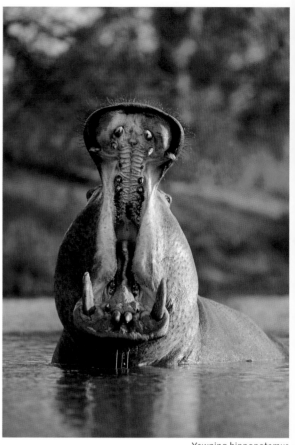

Yawning hippopotamus

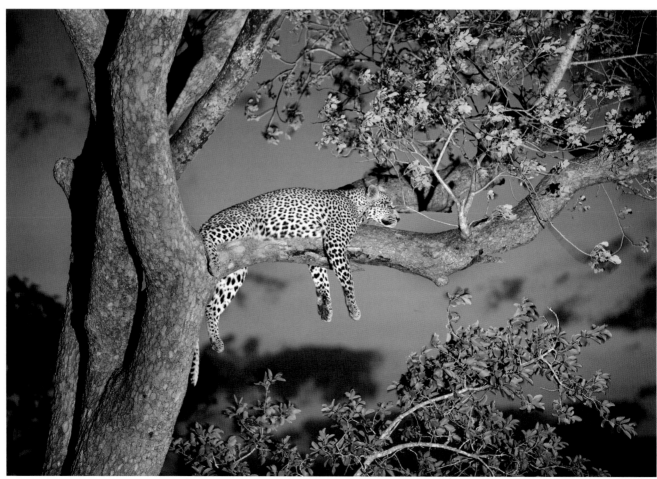

Leopard on tree trunk

Klipspringer antelope on a rocky outcrop

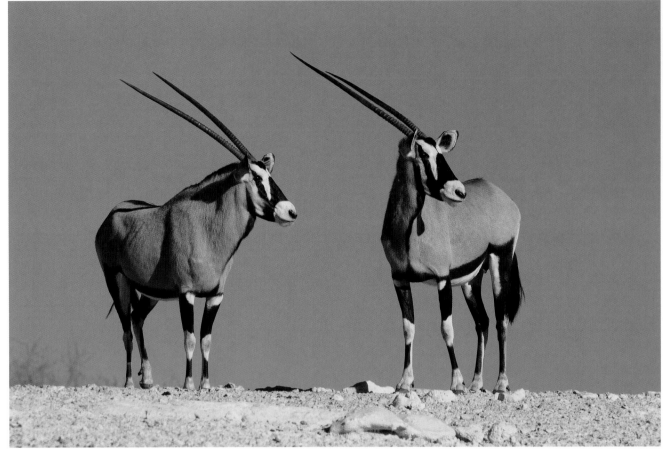
The gemsbok, a typical antelope of arid areas

Black-backed jackal

Kgalagadi

Location: In the north, bordering Namibia and Botswana
Significance: The entire transfrontier park is one of the largest conservation areas in the world

The Kgalagadi Transfrontier Park was declared in the 1990s and incorporates the Kalahari Gemsbok National Park in South Africa and the Gemsbok National Park in Botswana.

The Kalahari Gemsbok National Park was established in 1931, in order to conserve the wildlife of the area, including the gemsbok and other migratory animals. Its terrain is characterised by red sand dunes, dry riverbeds of the Nossob and Auob Rivers (which are said to flow only about once every century) and meagre vegetation. Underground water feeds some plant life, including the camelthorns, and the limited rainfall of 200mm per year sustains the fauna and flora. A surprising variety of animals occur, including large mammals such as lion, hyena, leopard, cheetah, and antelope such as eland, red hartebeest, springbok and blue wildebeest. More than 200 bird species, including vultures and raptors are found. This destination is also a favourite for avid photographers, due to its striking landscape and unique character.

The Kgalagadi Transfrontier Park is of immense size, and with a total area of more than 3.6 million hectares, it is not surprising that it counts as one of the largest game reserves in the world.

Interesting to know:

Kgalagadi means 'place of thirst', and indeed the heat and dryness of the area pose a daily challenge to its human and animal inhabitants. Temperatures range from 40°C or more on summer days, to below freezing on winter nights.

Suricate adult and young

Richtersveld scene

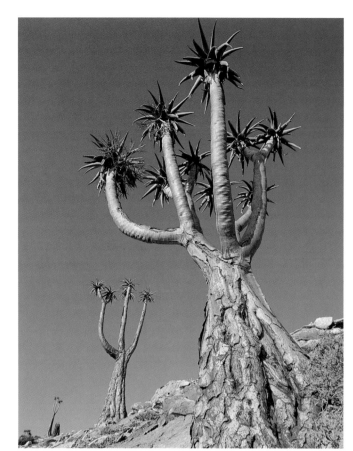

Aloe pillansii in the Richtersveld

!Ai-!Ais/Richtersveld

Location: Far north-western corner of the Northern Cape and the southern tip of Namibia
Significance: A cultural and botanical conservation area

!Ai-!Ais, a phrase borrowed from the San language, means 'hot, very hot' – a fitting name for this area where summer temperatures can reach 52°C. This transfrontier park is made up of the Richtersveld National Park in South Africa and Namibia's Ai-Ais Hot Springs Game Park.

The transfrontier park was established by international treaty in August 2003, and incorporates the Fish River Canyon (the second largest canyon in the world) and the Ai-Ais hot springs in Namibia. This arid landscape is unique because despite its inhospitable appearance communities of nomadic Nama people have inhabited it for centuries, and still have concessionary occupation rights. This agreement allows the indigenous peoples to continue to live off the land, which is managed jointly by them and the South African National Parks. The area is thus a significant one in terms of the preservation of South Africa's cultural heritage.

An area surprisingly rich in wildlife, the Richtersveld is home to the world's richest desert flora. These include aloes, quiver trees and the unique 'halfmens' tree (half human) which characterise the area. Additionally, a great variety of mammals, reptiles and birds are sustained by the moisture of the early morning fog that comes in off the cold Atlantic Ocean. Some animals to look for are the Hartmann's mountain zebra, ground squirrel, dassie rat, rock hyrax, and jackal buzzard.

Interesting to know:
The Richtersveld Cultural and Botanical Landscape has been designated by UNESCO as a World Heritage Site, not only due to its vast plant life but also because of the unique significance the area has for the Nama people.

Namaqualand

Location: North-western part of the Northern Cape
Famous for: Spectacular springtime floral splendour

Within the succulent desert (or succulent Karoo), the world's only arid biodiversity hotspot, lies an area called Namaqualand. This region is arid for most of the year, but after the annual winter rainfall this usually barren area explodes into bloom during the early springtime (August/ September) in what is known as the Namaqualand daisy season.

Namaqualand in its entirety extends from the Atlantic Ocean on the west coast to the town of Pofadder, and from the north within Namibia to Garies in South Africa for almost 1 000km. The area is approximately 440 000km², and is home to great botanical diversity. Great Namaqualand lies north of the Orange River in Namibia, but south of the Orange River, within South Africa's Northern Cape, lies the Little Namaqualand. This area is also rich in alluvial diamonds, which are swept by the Orange River to the west coast, and this has led to numerous mining towns springing up in the dry landscape. The coast of Namaqualand is very picturesque and dotted with fishing villages. One such village is Hondeklipbaai – 'Dogstone Bay', named after a large boulder that looks like a giant hound. Namaqualand, containing the world's richest succulent flora, is also home to the Nama-qua Speckled Padloper, the world's smallest tortoise.

Interesting to know:
The Cape of Good Hope governor Simon van der Stel saw the Namaqualand daisy season as an amazing spectacle and hence, named one of the towns in Namaqualand Spektakelberg. He also discovered the copper deposits in the area in 1685, but for decades before that the indigenous nomadic Nama tribes had been smelting copper and using it.

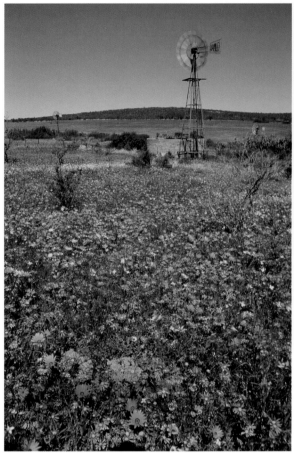

A field of flowers in Namaqualand

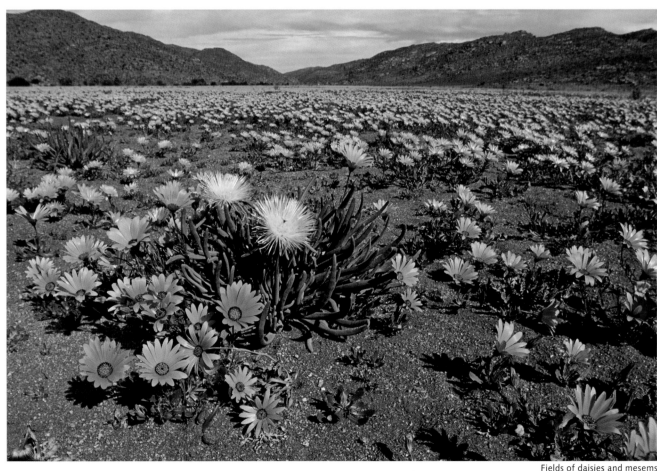

Fields of daisies and mesems

Flower splendour

Namaqualand daisies

Place of Great Noise

Location: On the Orange River west of Upington
Famous for: Spectacular views

The Augrabies Falls offer sights and sounds unexpected in this arid region. The name is derived from *Ankoerebis*, meaning 'place of great noise' in the language of the local indigenous people. As the name suggests, the waterfalls in full spate produce a deafening noise that is not easily forgotten.

They are 56m high and are created as the Orange River is divided into numerous channels before it cascades down into the gorge. There is a dramatic fall into a 240m deep gorge cut through the granite, which continues for 18km as the Orange River makes its way to the Atlantic Ocean. The combination of the volume of water and the unique shape of the gorge produces the loud roar that characterises the place. The falls carry a vast amount of water, and have recorded a top volume of 7 800m^3 per second (during the 1988 floods), which is more than three times the high-season flow rate of the Niagara Falls (2 400m^3 per second). In the area is Moon Rock, a large dome of rock that provides a spectacular view of the park, and Oranjekom and Ararat, from where the gorge area can be seen. Echo Corner is another favourite: a spot that produces long echoes, provides a stunning scenic view, and also forms the start of the Gariep 3-in-1 adventure. This involves canoeing, hiking and mountain-biking.

Interesting to know:
The Augrabies Falls National Park is rich in fauna and flora, including a renowned diversity of succulents. Verreaux's eagles (black eagles) nest there, as rock hyraxes, their preferred prey, are plentiful.

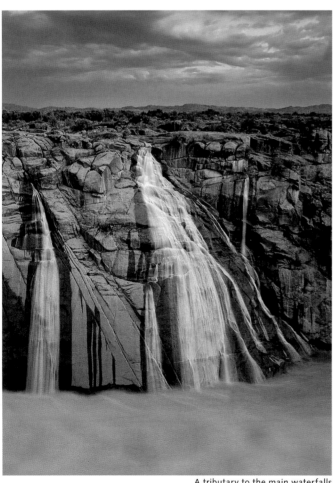

A tributary to the main waterfalls

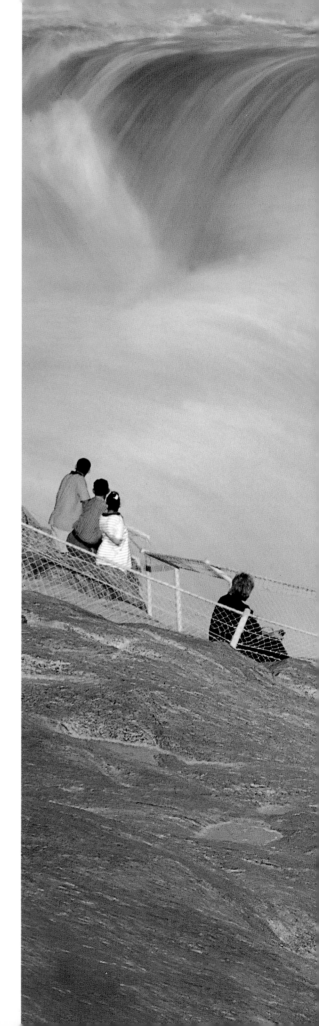

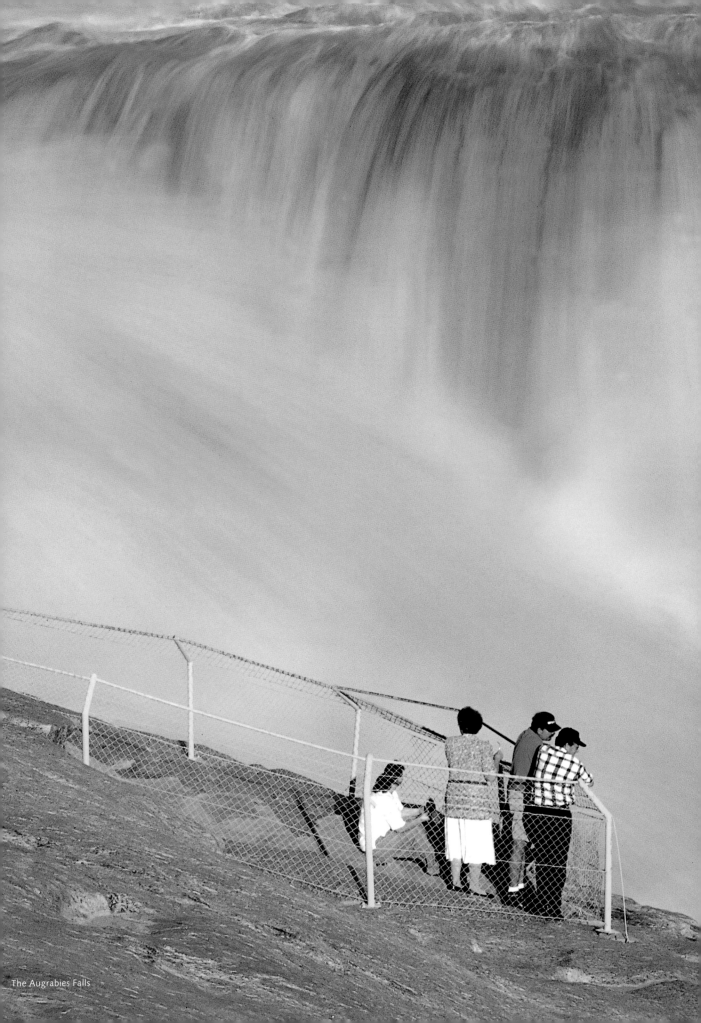

The Augrabies Falls

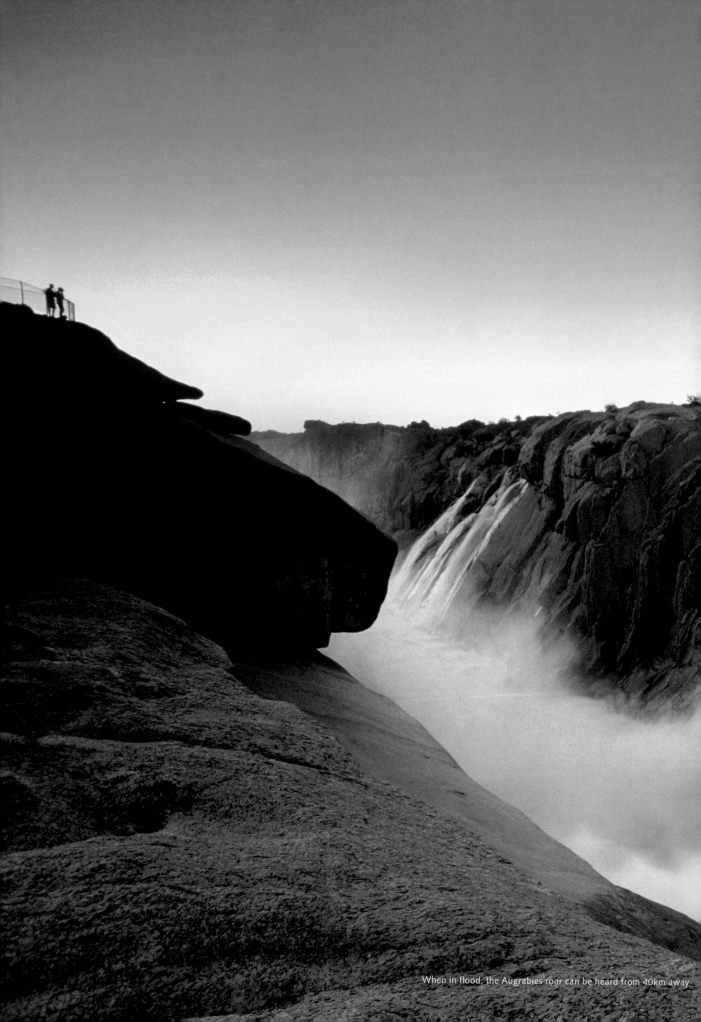

When in flood, the Augrabies roar can be heard from 40km away

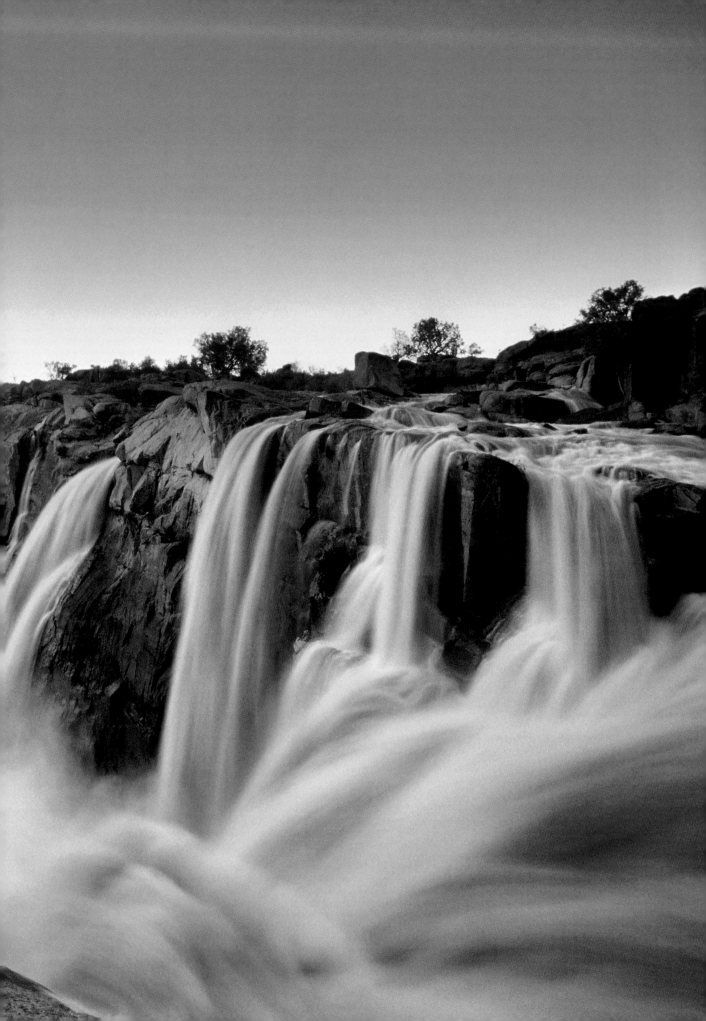

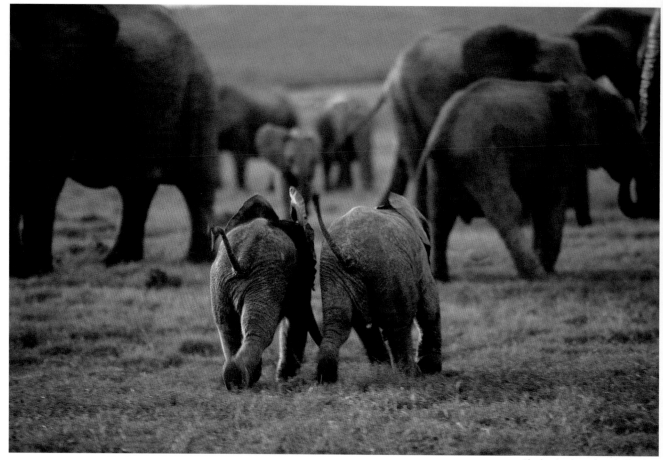

Elephant calves play-challenging

Greater Addo

Location: The Sundays River region, near Port Elizabeth
Significance: First proclaimed in 1931
Recently extended to form the greater park
Home to the Big Seven

Addo Elephant National Park was originally established for the conservation of elephant, in particular the 11 remaining elephant in the region at the time. The park has recently been expanded and the Greater Addo National Park is now 3 600km² in size and stretches from the fringes of the Great Karoo, over the Zuurberg Mountains, across the Sundays River Valley, along the hilly country covered by carpets of impenetrable blue-green thicket, and all the way to the coast. Here the Sundays River forms an impressive estuary before it spills into Algoa Bay. The park also includes a marine section with two offshore islands. From the mouth eastwards, a spectacular 65 000-year-old dune field, with heights of 150m in places, averaging more than 2km in width, forms a sand barrier between the shoreline and the unique coastal forests of Alexandria.

Today the elephant numbers have grown to more than 500 and the Park is home to many other animals such as disease-free Cape buffalo, endangered black rhino, lion and spotted hyena. The addition of the marine section makes the park the only one with the Big Seven since it also has the whale and great white shark.

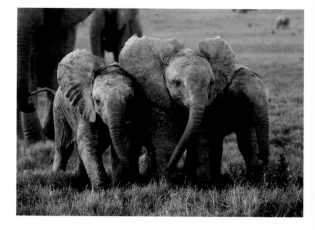

Interesting to know:
Bird Island is of particular conservational importance as it provides a breeding habitat for gannets and penguins. The Greater Addo Park has great biodiversity, encompassing seven of South Africa's eight land biomes. It is visited by more than 120 000 tourists every year, more than half of whom are foreign visitors.

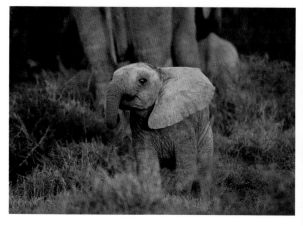

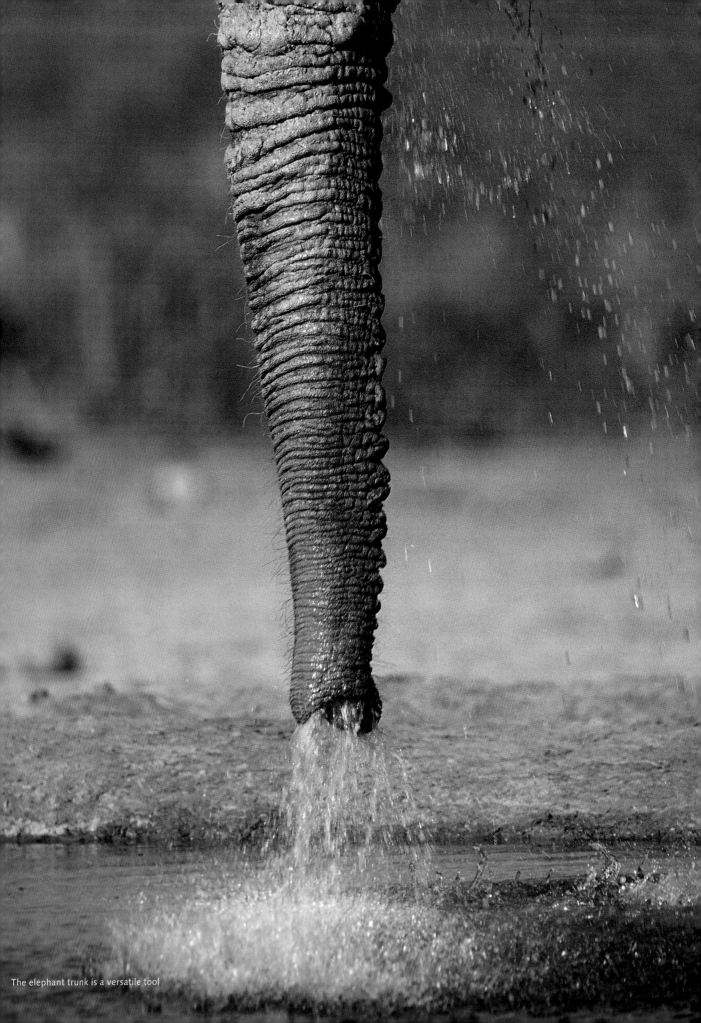

The elephant trunk is a versatile tool

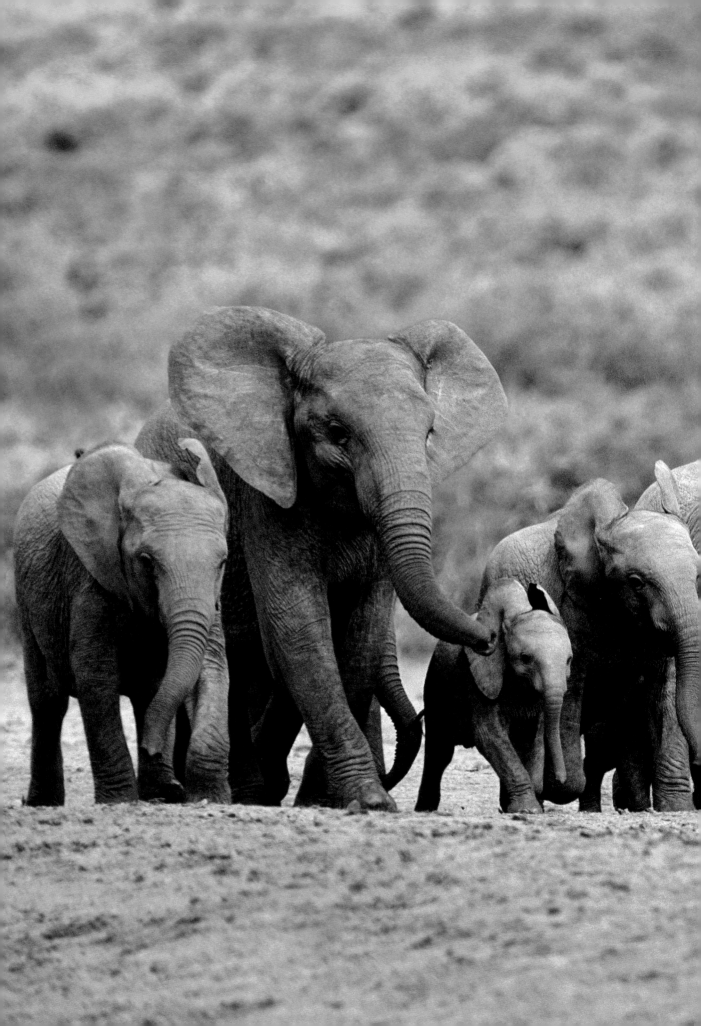

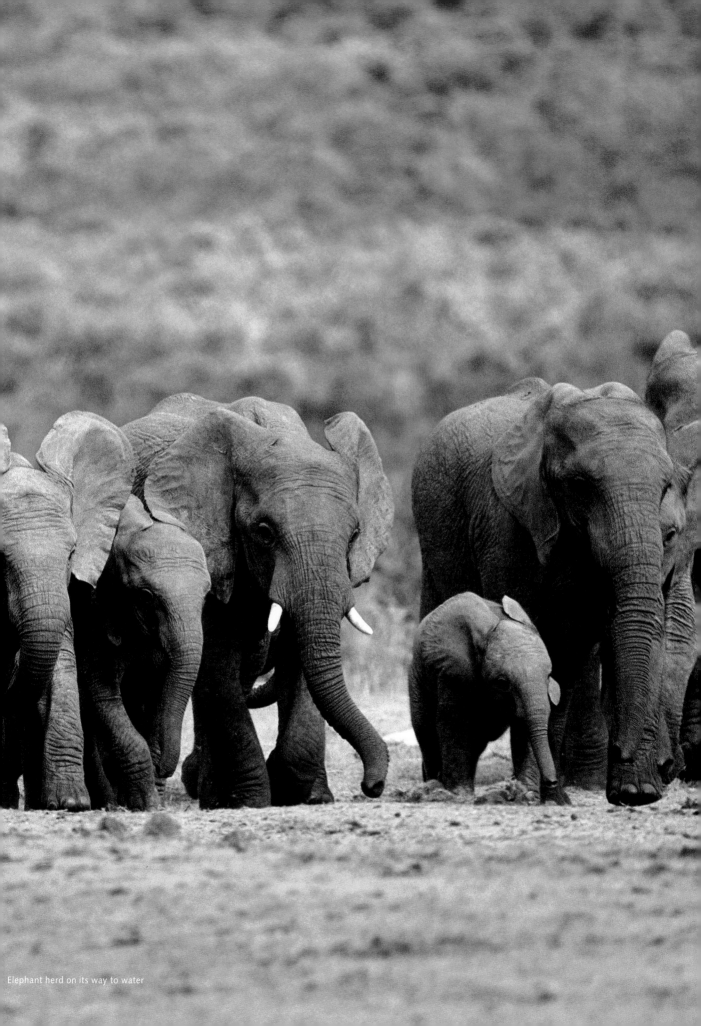

Elephant herd on its way to water

Gigantic waves are typical of the Tsitsikamma coast

Tsitsikamma

Location: Southern coast of the Eastern Cape
Famous for: Scenic beauty
 Tsitsikamma National Park
 The Otter, Dolphin and other hiking trails
 Giant yellowwoods

The Khoisan word *Tsitsikamma* means 'place of abundant sparkling or clean water'. Famous as a place of great beauty, it is water, both fresh and salt, that characterises the area. Ancient indigenous forests of yellowwood, stinkwood, ironwood, hard pear and kamassi cover the hinterland and the slopes of the Tsitsikamma Mountains. Ferns, mosses, fungi and fynbos dotted with erica and protea species are a delight to the eye.

The first marine national park, the Tsitsikamma Coastal National Park was proclaimed in 1964 and established to protect the marine environment and coastal forest vegetation. This marine conservation area incorporates 80km of coastline, including tidal zones, reefs and deep-sea areas, as well as beach ecosystems and the rivers that carve their way down to the shore. Animals prevalent in the area include dolphins and southern right whales in the ocean, while otters, bushpig, various other small mammals and birdlife dominate the land. Also in the area is the spectacular Storms River Bridge, which spans the deep gorge near the river mouth.

Interesting to know:
Starting at the Storms River Mouth, the famous Otter Trail is a 42km hike along the craggy Cape coast and traverses rocky cliffs, rivers and gullies to the small village of Nature's Valley. It was the first formal hiking trail to be established in South Africa.

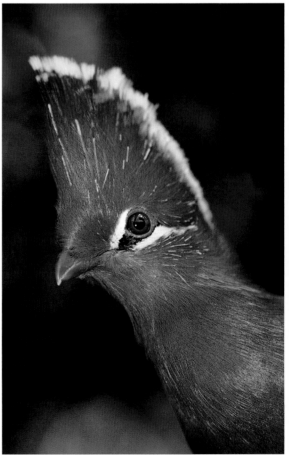
Knysna turaco

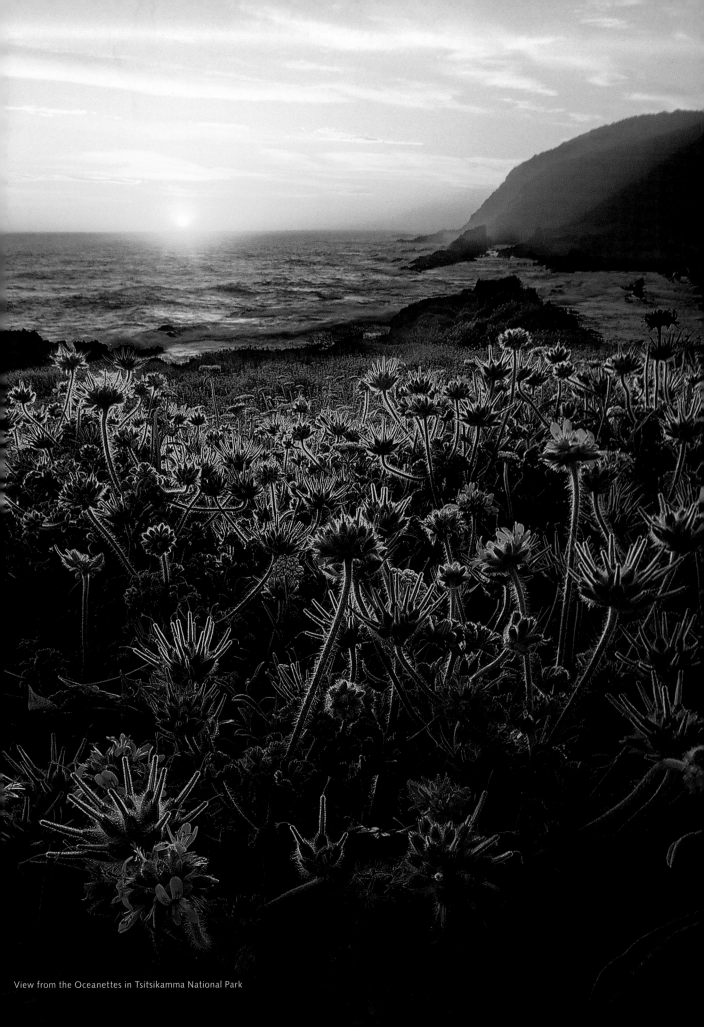
View from the Oceanettes in Tsitsikamma National Park

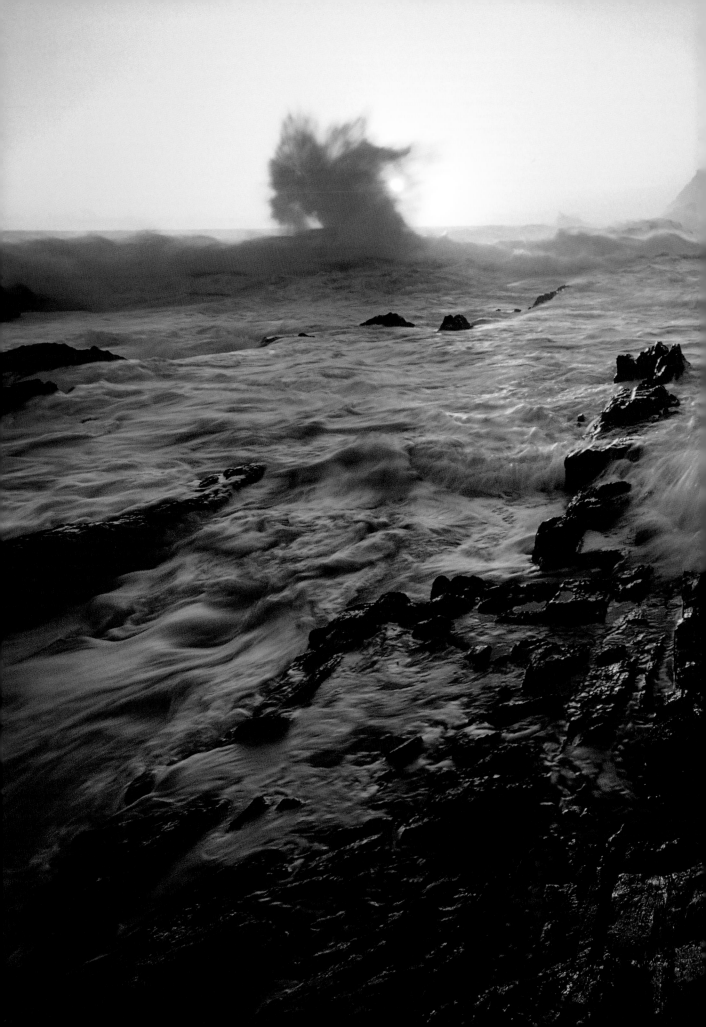

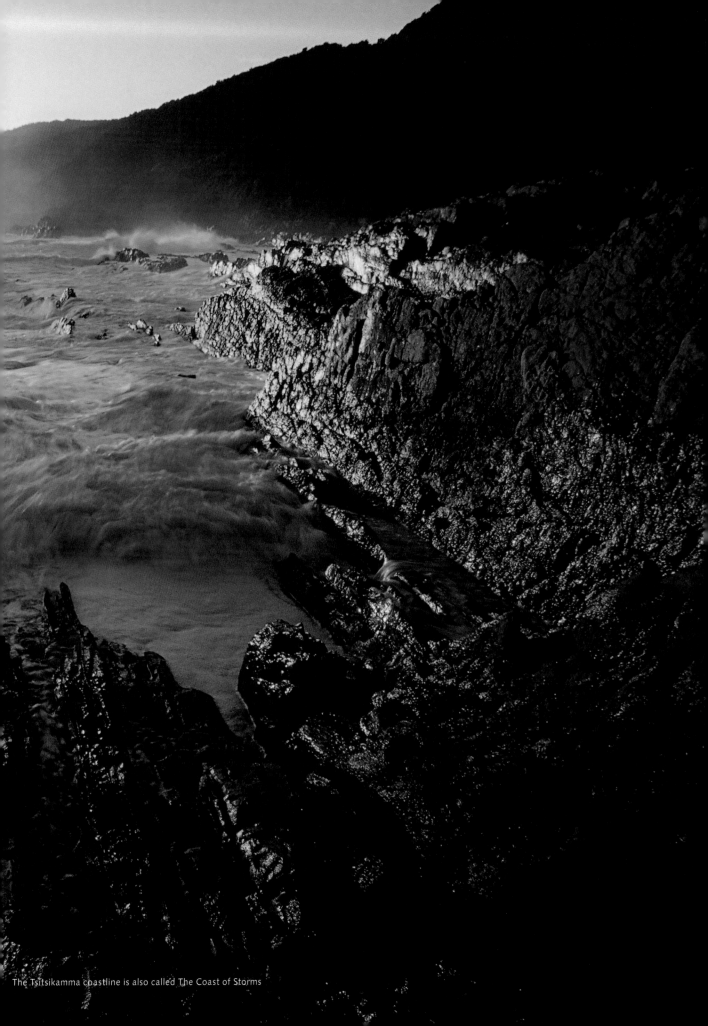

The Tsitsikamma coastline is also called The Coast of Storms

Cathedral Cave

Golden Gate

Location: The Golden Gate Highlands National Park is situated in the foothills of the Maluti Mountains in the north-eastern Free State

Famous for: The rare bearded vulture
Spectacular scenery with sandstone cliffs
Autumn colours in April
Fossilised dinosaur eggs

The park derives its name from the brilliant shades of gold seen when the setting sun shines on the impressive sandstone cliff face of the 'Brandwag' (sentinel), a massive rock structure standing sentry where the road meanders through the Little Caledon River valley. The mountain slopes and grassy hills are part of the Drakensberg escarpment and grazed by typical grassland antelope species such as the grey rhebuck and the mountain reedbuck.

The montane habitat attracts special birds, including the rare bearded vulture and the equally rare bald ibis, which both breed on ledges of sandstone cliffs. A hide at the 'vulture restaurant' allows close-up viewing of these majestic birds feeding. Of the several endemic species, the ground woodpecker is one of the possible sightings.

The invigorating cool highveld summers with the possibility of thunderstorms in the afternoon are as attractive to visitors as the cold winters with occasional snow transfiguring the park.

Interesting to know:
Established in 1963, the park has an unsurpassed variety of rock shapes and colours. Various caves in the sandstone rocks offered shelter to the San, and evidence of their occupation can still be seen in the preserved rock art.

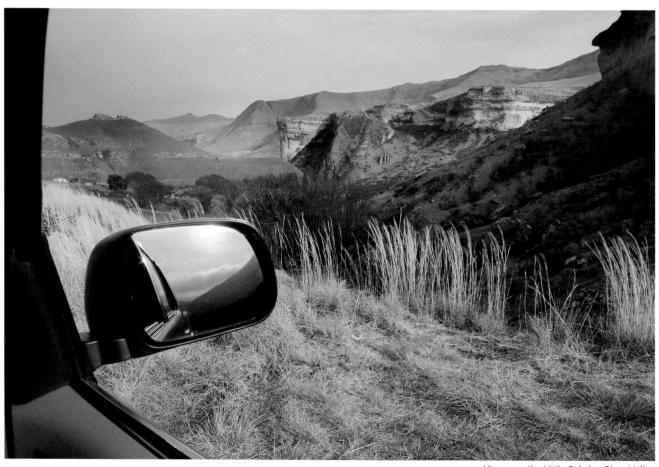

View over the Little Caledon River Valley

Horse riding in Golden Gate National Park

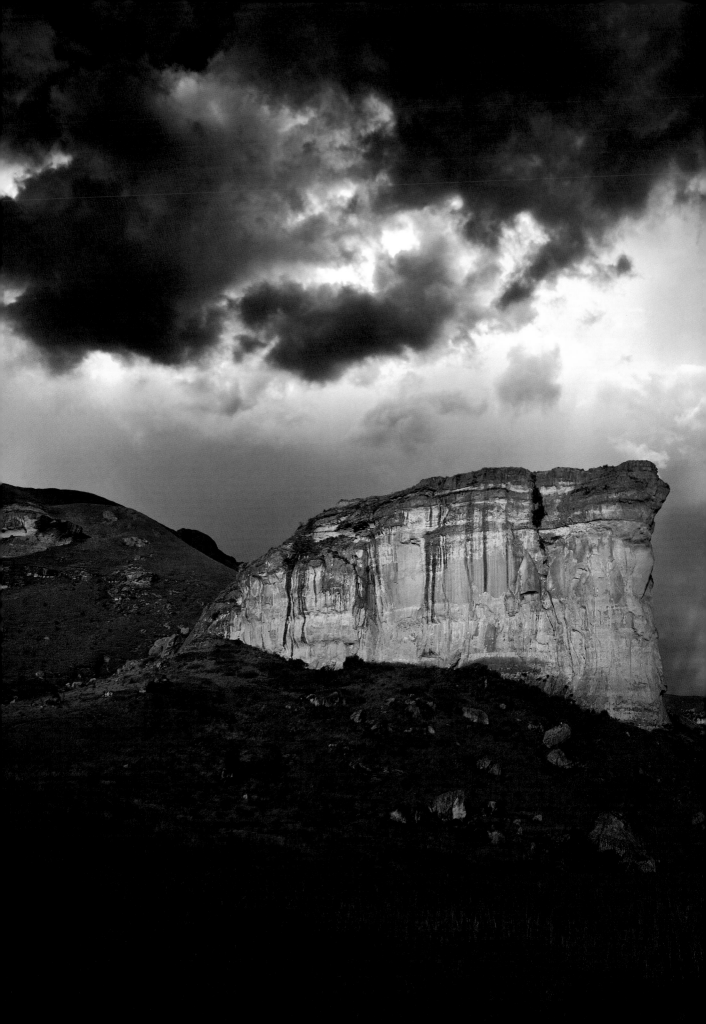

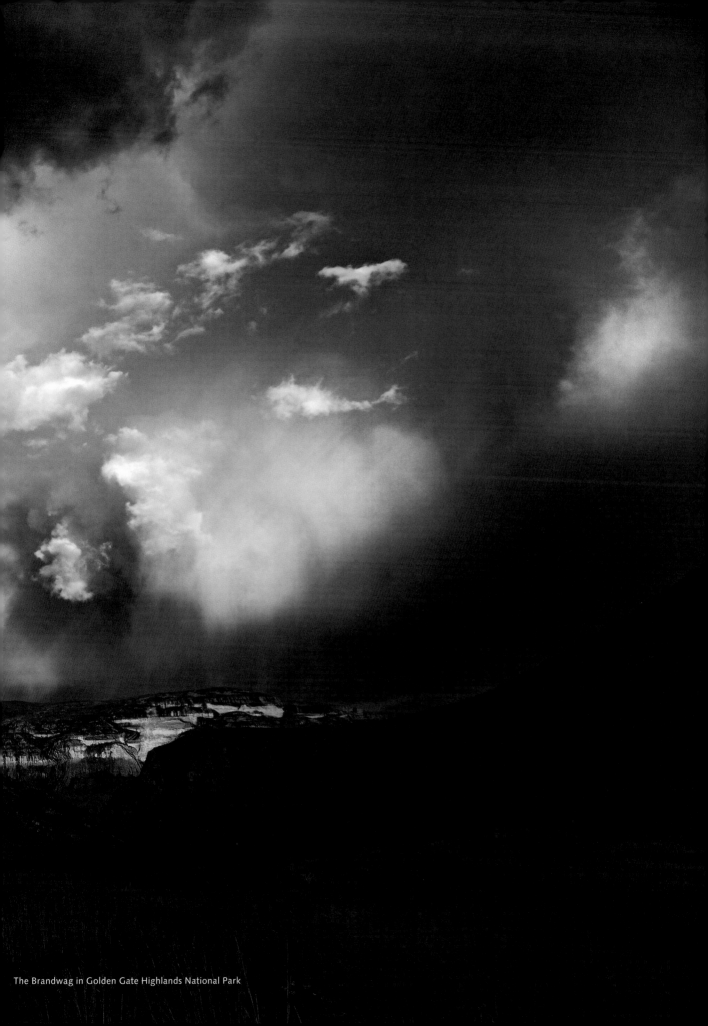

The Brandwag in Golden Gate Highlands National Park

Pincushions *(Leucospermum sp)*

Pincushions *(Leucospermum conocarpodendron)*

Cape Floral Kingdom

Location: Southern and south-western Cape
Significance: A protected and unique group of plants
One of six recognised floral kingdoms in the world
Forms part of the Cape Floral Region Protected
Areas World Heritage Site
A multitude of endemic species

Although the Cape Floral Kingdom is the smallest of the six floral kingdoms in the world, it is considered to be the richest, with more plant species than the whole of Europe. Fynbos makes up 80% of it. At 90 000km^2 the region covers an area roughly the size of Portugal.

Fynbos is a group of more than 7 700 plant species, of which 70% are found nowhere else on earth. Essentially a shrubland, it presumably derives its name from the many fine-leaved shrubs (fine bush) and possibly also because the woody part of the vegetation is too small or delicate (fyn) to be used as timber.

There are over 600 types of erica (ericoids or heath-like shrubs), with only 26 other heath plants found in the rest of the world. The other growth forms include the proteoids (protea shrubs), the restoids (reed-like plants) and geophytes (bulbous herbs). The Cape's Mediterranean climate contributes to the growth of this plethora of species, and in fact the fynbos biome resembles the vegetation found in Mediterranean countries.

Interesting to know:
Fynbos is also found on Table Mountain, which itself is home to 2 200 plant species, more than are found in the United Kingdom. It may comprise only 0.5% of Africa's total land area, but the Cape Floral Kingdom contains half the plant species on the subcontinent and 20% of all plant species in Africa.

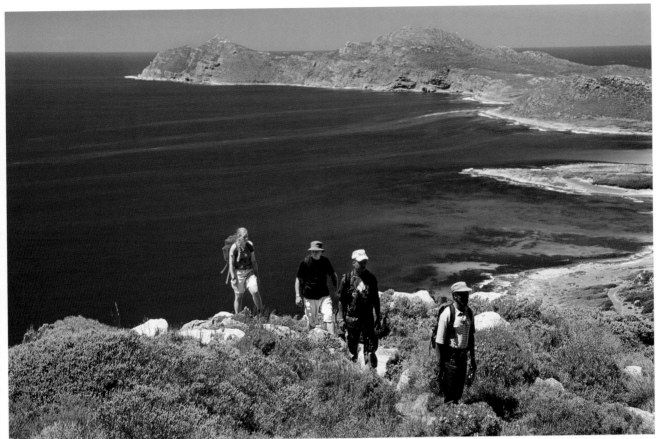

Hikers on a trail in the Cape Point Nature Reserve

Cape Point

Location: The most south-westerly point of Africa
South of Cape Town, on the Cape Peninsula
Significance: A treacherous and dangerous area for ships

Cape Point is one of three peaks on the Cape Peninsula, a hook-shaped land mass south of Cape Town and Table Mountain. A favourite among visitors, this landmark offers amazing views of rugged ocean coastline, as well as evidence of how treacherous this beautiful area must have been for the European settlers' exploration of the Cape.

Cape Point Reserve is part of the Table Mountain National Park and has a total area of 7 750 hectares. Its 40km coastline has sheer cliffs, rocky outcrops and occasional sandy beaches. Cape Point's sister peaks are Cape of Good Hope and Cape Maclear.

When Portuguese seafarers rounded the Cape and began to explore Africa's southern coastline, the peninsula was named 'Cape of Storms' by Bartolomeu Dias in 1488, but was renamed 'Cape of Good Hope' by Portugal's King John II in 1580. The peninsula is known as a treacherous coastline, and many ships have run aground on its rocky stretches. In 1857 a lighthouse was built on Cape Point peak, but due to its height it was often obscured by fog and a second one was erected at a lower level between 1913 and 1919. The old lighthouse can be visited today, by taking the funicular railway followed by a short flight of steps.

Interesting to know:
Cape Point is widely but incorrectly believed to be the southern-most tip of Africa. That point is in fact Cape Agulhas, about 200km south-east of Cape Point. Cape Agulhas is also where the Indian and Atlantic oceans meet, and not at Cape Point as is also believed. However, two currents – the cold Benguela current and the warm Agulhas current – do meet at Cape Point.

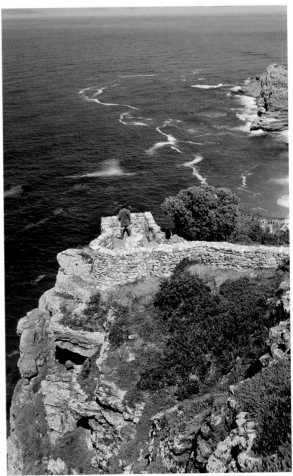

Looking towards Cape Point

Forest stream

Garden Route

Location: The coastal strip along the N2, roughly from the
Breede River to the forests of Tsitsikamma
Significance: Pristine coastline and other natural beauty
Includes the new Garden Route National Park

In terms of beauty and biodiversity, the Garden Route is one of South
Africa's jewels. This route straddles two provinces, the Western and the
Eastern Cape and also runs through the recently proclaimed Garden
Route National Park. The road meanders through diverse landscapes in-
cluding several towns and coastal resorts, marine and inland protected
areas such as the Wilderness lakes, the Knysna estuary, lowland fynbos,
mountain catchments, and indigenous forests.

The Garden Route National Park is unique in that it incorporates
two other formerly independent national parks, Tsitsikamma and
Wilderness. Several diverse stakeholders administer and manage the
huge park of approximately 121 000 hectares. In the long run, the
integrated landscape management will improve the ecotourism and
conservation potential of the area, better protect important ecosys-
tems, allow sharing of resources, including fire and alien clearing pro-
grammes, and enable land consolidation. It is the first national park
of its kind in the world and will serve as a new kind of conservation
model for the future.

Interesting to know:
Whales seen at various places on the Garden Route include the
southern right, humpback, Bryde's, and even orca whales. Bottle-
nosed, humpback and common dolphins are a regular sight.

Knysna

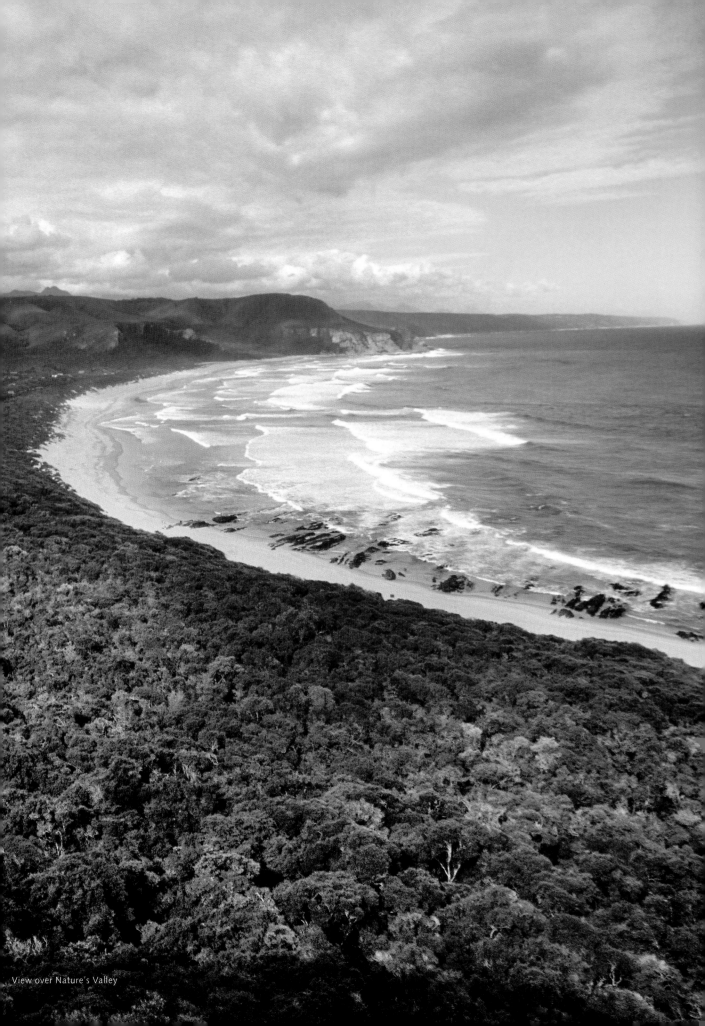

View over Nature's Valley

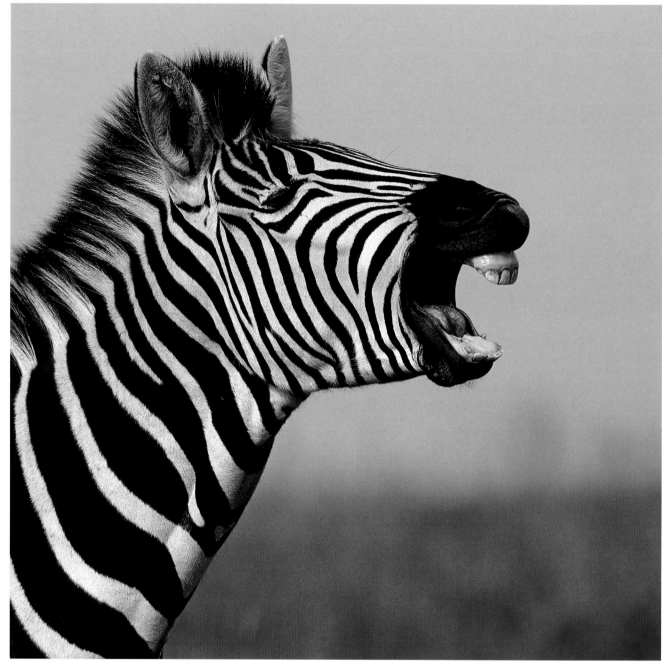

Plains zebra *(Equus quagga)*

Pilanesberg

Location: North-west of Rustenburg
Significance: One of the largest game reserves in South Africa
Covers an area of 55 000 hectares
Home to the Big Five
Malaria-free game reserve

The last time that there was a large volcanic eruption in the North West Province was about 1 300 million years ago when South Africa was still part of the earliest known supercontinent called Rodinia. The extinct volcano crater, which was turned into a game reserve in the 1970s, is not only ancient in geological terms, but rates high amongst the world's outstanding geological phenomena. It is the most perfect example of an alkaline ring complex.

The area has survived ages of erosion and stands high above the surrounding bushveld plains. Today it is a transitional zone between wet and dry savannah, with syenite outcrops, thickly forested ravines, typical savannah and grasslands, as well as lightly wooded areas. Typical dry area species such as springbok, brown hyena, the red-eyed bulbul and camelthorn trees occur together with impala, the dark-capped bulbul and Cape chestnut trees, which prefer a moister environment.

The creation of the Pilanesberg National Park is considered one of the most ambitious programmes of its kind to be undertaken anywhere in the world.

Interesting to know:
Called Operation Genesis, the establishment of this park involved extensive game-fencing of the reserve and the reintroduction of long-vanished species. Pilanesberg is one of the first game reserves to engage in successful elephant translocation.

A Cape vulture flying over the Hartbeespoort Dam

Magaliesberg

Location: Near Rustenburg
Straddles the North West and Gauteng provinces
Significance: Among the oldest mountain ranges in the world
Breeding colonies of Cape vultures
120km-long mountain range

At an age of 2 400 million years, which is 100 times older than the Himalayas and even older than the extinct volcano of Pilanesberg, the Magaliesberg range is one of the special places in South Africa. It was named after Magali, who was the chief of the Po people who lived there during the 1800s.

The antiquity, deep gullies and gorges, the waterfalls and streams, all contribute to the magnificence of this fascinating mountain range,

but it is the high, sheer cliff faces of quartzite rock with their ideal nesting ledges that attract one of the most threatened bird species to this kingdom in the sky. Almost 400 breeding pairs of Cape vultures have made this their home – one of the largest populations of this species in South Africa. Cape vultures are under threat due to poisoning, collisions with cars, power line electrocution, and a decline in their natural food sources. The protected natural environment of the mountain is a relatively safe haven for them.

Interesting to know:
The Magaliesberg Cape Vulture Programme is being conducted in order to learn the habits of the birds, and the reality of how power lines affect their population. Using various means, including GPS technology, scientists are identifying the main causes of the species' population decline and how power lines can be made more bird-friendly.

Nyala antelope are typical of Ezemvelo Parks

Ezemvelo

Custodians: Ezemvelo KZN Wildlife
Famous for: Saving the white rhino from extinction
Developing successful capturing and darting
techniques for game relocations

Ezemvelo KZN Wildlife has combined land holdings of 7 508km² –
about 8.3% of the province's area – and is the principal custodian of
KwaZulu-Natal's wildlife and environmental resources. Several private
game reserves also make a huge contribution towards wildlife conser-
vation in the province.

Ezemvelo is the Zulu term for 'environment'. Building on the out-
standing achievements of its predecessors in Natal and KwaZulu, this
body's continuing contribution to conservation and ecotourism has
brought it national and international acclaim. It manages 110 protected
areas, ranging in size from five to 260 000 hectares and containing a
wide range of indigenous and endemic species.

Ezemvelo KZN Wildlife nurtures partnerships with people, and
through community involvement in ecotourism it improves the lives of
many previously disadvantaged groups. Ezemvelo KZN Wildlife aims
to build on these past successes and grow the successful relationship
between conservation, people, and ecotourism.

Interesting to know:

Saving the white rhino was one of Ezemvelo KZN Wildlife's greatest
achievements. Today white rhino numbers have increased to more
than 5 300 in South Africa alone, but now the black rhino numbers
have plummeted. More than 98% of the original black rhino popu-
lation has been wiped out over the last 20 years and serious efforts
have to be made to save it from extinction.

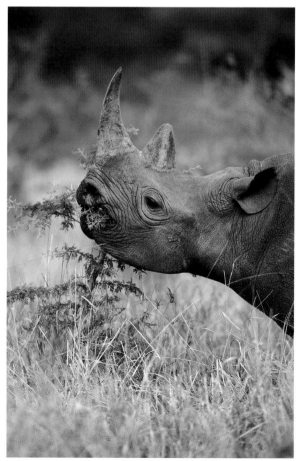

The endangered black rhino *(Diceros bicornis)*

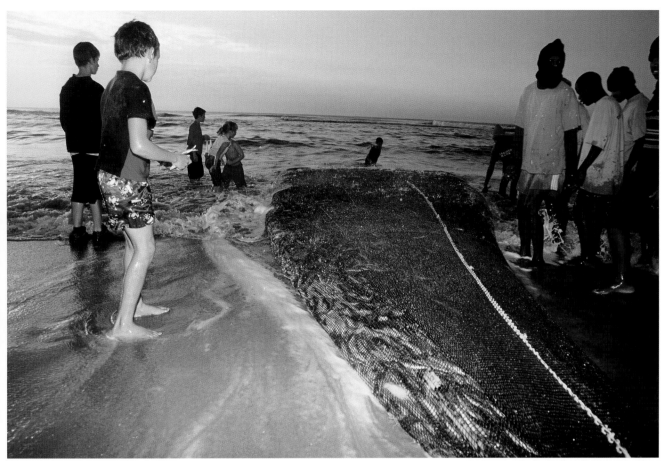
Sardines on the South Coast of KwaZulu-Natal

Biggest Shoal on Earth

Location: From Port St Johns northward along the coast
Significance: An annual event in the winter months
One of the largest marine events on the planet

Winter on the South Coast of KwaZulu-Natal is annually the scene of the famous 'Sardine Run' when sardines or pilchards from the Agulhas Banks of the Western Cape in the south, start migrating northwards. They move along a cold counter-current that runs in the opposite direction to the warm south-flowing Agulhas current coming from the tropics.

Sardines often become trapped on the beaches in large numbers because the narrow counter-current is eventually squeezed out as it reaches the South and finally the North Coast of the province. Many species of fish, sharks, marine mammals and birds follow the shoals to participate in the feeding frenzy.

Pods of dolphins join together to form even bigger groups of several thousands. Copper sharks and dolphins are often seen herding the sardines together to form close-packed 'bait balls' into which Cape gannets plunge like jet-fighters to get their share. The event also coincides with the annual migration of humpback whales that move north into warmer water to mate and calve.

Interesting to know:
The annual sardine run is one of the largest marine events on the planet and the gigantic waves of silvery sardines followed by hungry predators is a spectacular show. Some fish are driven inshore and netted by fishermen, others are trapped in the breakers and washed ashore. When this happens, people join the feast and participate in a collecting frenzy.

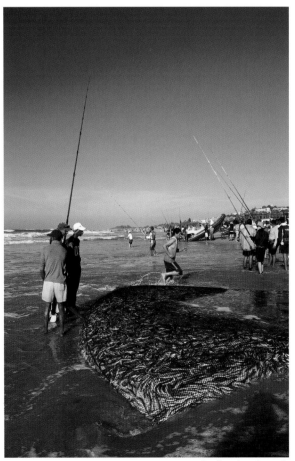
Sardines in seine nets

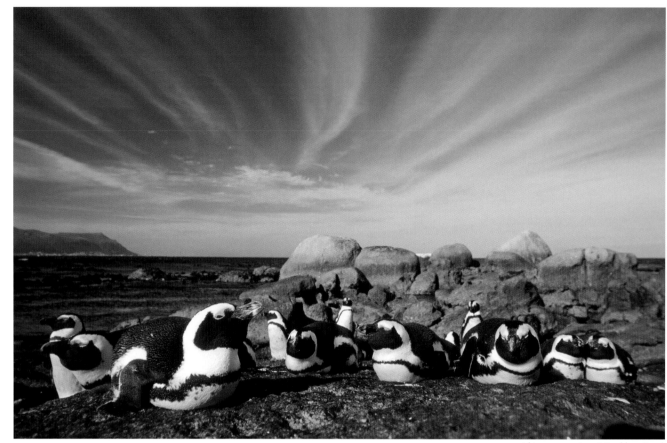

African penguins at Boulders Beach

African Penguins

Location: Boulders Beach near Simonstown
Habitat and habits: Found mainly in land colonies on islands off the South African coast
Seldom settle on the mainland as at Boulders
Feed mainly on fish

A colony of penguins started occupying Boulders Beach near Simonstown from the 1980s. It is believed these ecologically vulnerable penguins chose this bit of suburbia and public beach as their home due to its favourable position on False Bay with its shoals of fish and fewer predators. The penguins are often quite tame and are known to lie in the sun amidst people visiting the beach. There are also walkways onto the beach so the public can view the penguins. Boulders Beach is now a protected area and part of the Table Mountain National Park. Stony Point at Betty's Bay and places along the West Coast are other favourite beaches for penguins.

The African penguin is also known as the jackass penguin. It gets this name from the donkey-like sound of its call. With a body weight of 3–4kg and a height of 70cm, they are most comfortable in water; they can dive to a depth of 1 000m and stay under water for up to 20 minutes before resurfacing for air.

Interesting to know:
The biggest threat to penguins today, besides predators such as seals, leopards, dogs and cats, are man-made environmental hazards. Oil spills from ships damage the birds' feather layers, but thanks to the Southern African National Foundation for the Conservation of Coastal Birds (SANCCOB) the penguins can be taken care of if affected by oil spills. SANCCOB is considered the most successful sea bird rehabilitation centre in the world.

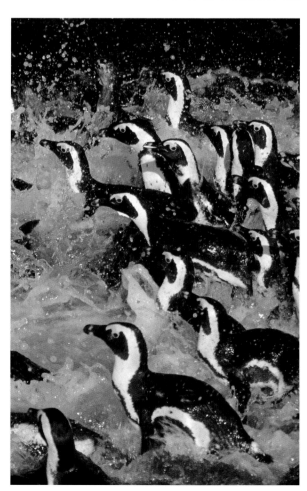

Aloe arborescens in Kirstenbosch Gardens

Kirstenbosch

Location: Eastern slopes of Table Mountain, Cape Town
Significance: Founded in 1913
A window on the country's rich floral heritage

Kirstenbosch is one of the first botanical gardens in the world founded to preserve the flora indigenous to its own country. It is the flagship of the eight national botanical gardens in South Africa that are situated in five of the country's eight biomes. With an area of 528 hectares, 36 hectares of which are cultivated garden, it is also the largest in South Africa.

Long before European settlers arrived, the area was inhabited by indigenous people, whose stone implements have been found there. With the establishment of a Dutch colony, a boundary hedge of wild almond was planted in 1660, part of which can still be seen in Kirstenbosch Gardens.

In 1811, the British, who ruled the Cape at the time, made a grant of the land, which was then owned by various families over the years. In 1913, it was set aside as Kirstenbosch and the gardens were established by Professor Pearson, head of Botany at the South African College. Today these magnificent gardens, which extend up the mountainside, include a greenhouse with plants from the savannah, fynbos and Karoo biomes, and an unrivalled outdoor collection of Cape flora, including numerous proteas, a plant for which the Western Cape is famous. (The king protea is the national flower of South Africa.)

Interesting to know:
Kirstenbosch attracts not only local and visiting nature lovers in search of a quiet time outdoors, but also more adventurous types who are keen to hike along the slopes and contour paths on the edge of the gardens. One of the trails goes up Skeleton Gorge and is a popular route to the summit of Table Mountain.

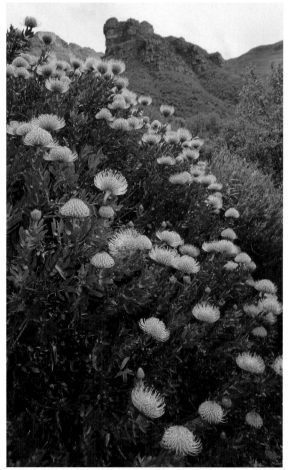

Pincushion proteas *(Leucospermum cordifolium)*

Activities

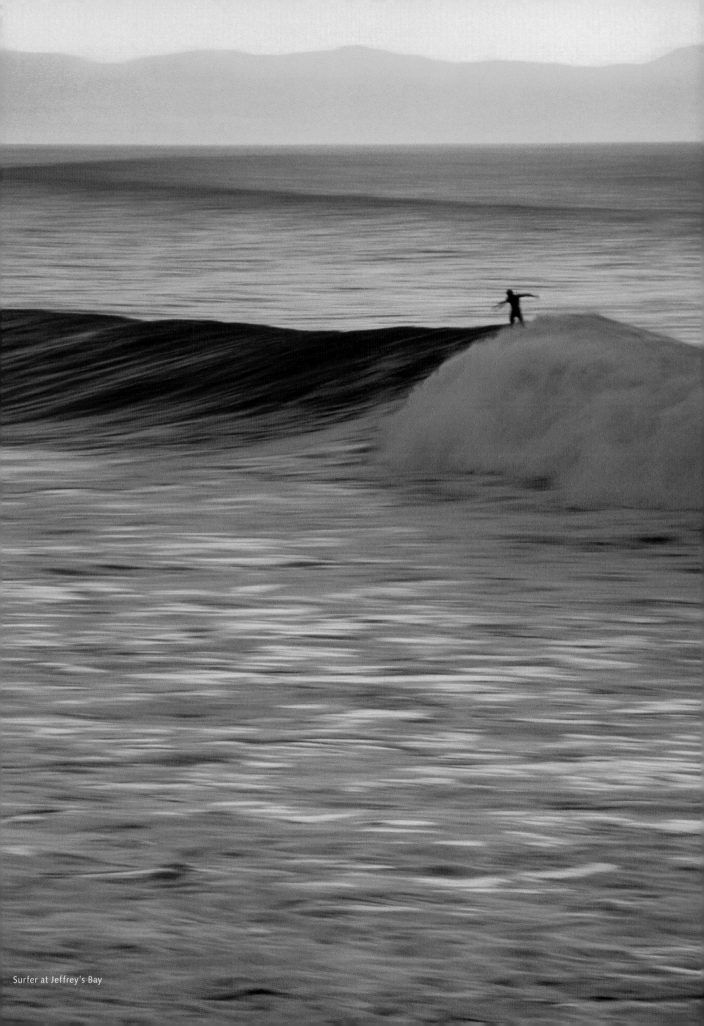

Surfer at Jeffrey's Bay

Wildlife Safaris

Location: South African National Parks (SANParks)
Provincial and privately-owned game reserves
Nature reserves and conservancies

Famous for: The best eco-tourism experiences in Africa
Eight biomes with associated game species
Huge tracts of pristine wilderness
Several World Heritage Sites

South Africa with its excellent travel infrastructure has become the preferred destination for visitors who wish to see Africa's magnificent wildlife in its natural state and experience the romance and fascination of the African bush. Although vast stretches of arable land have been transformed for agriculture and industry, and despite urbanisation and sprawling suburbia, South Africa is still wild at heart and offers nature lovers a feast for the eyes and special experiences in its extensive parks and game reserves.

These parks may be national, provincial or municipal, or even privately owned. National parks enjoy the highest legal protection and human activity is strictly controlled, while exploitation for personal gain is prohibited. All game reserves are governed by specific rules and regulations for the sake of conservation.

Interesting to know:

Wildlife safaris are journeys to wild places – some offer top-class luxury accommodation in the bush, others are suitable for those who wish to travel and stay closer to the earth to feel the magic, hear the noises and breathe the fresh and clean air of the African nights. There is something for everybody – from self-drive safaris to those conducted by well-trained safari guides.

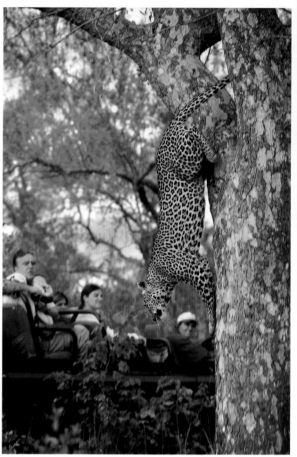

A game drive in the Sabi Sand

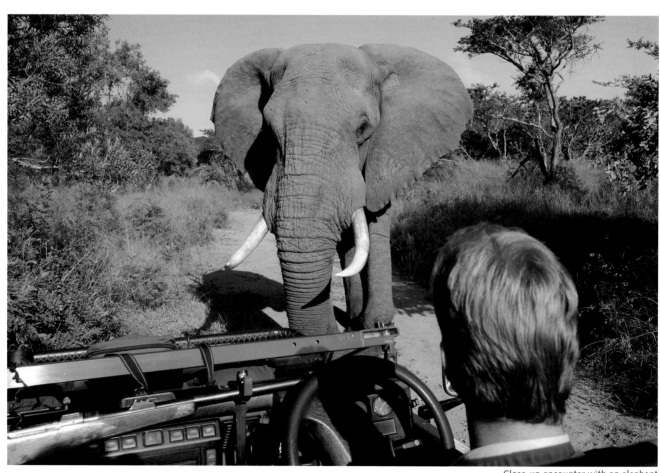

Close-up encounter with an elephant

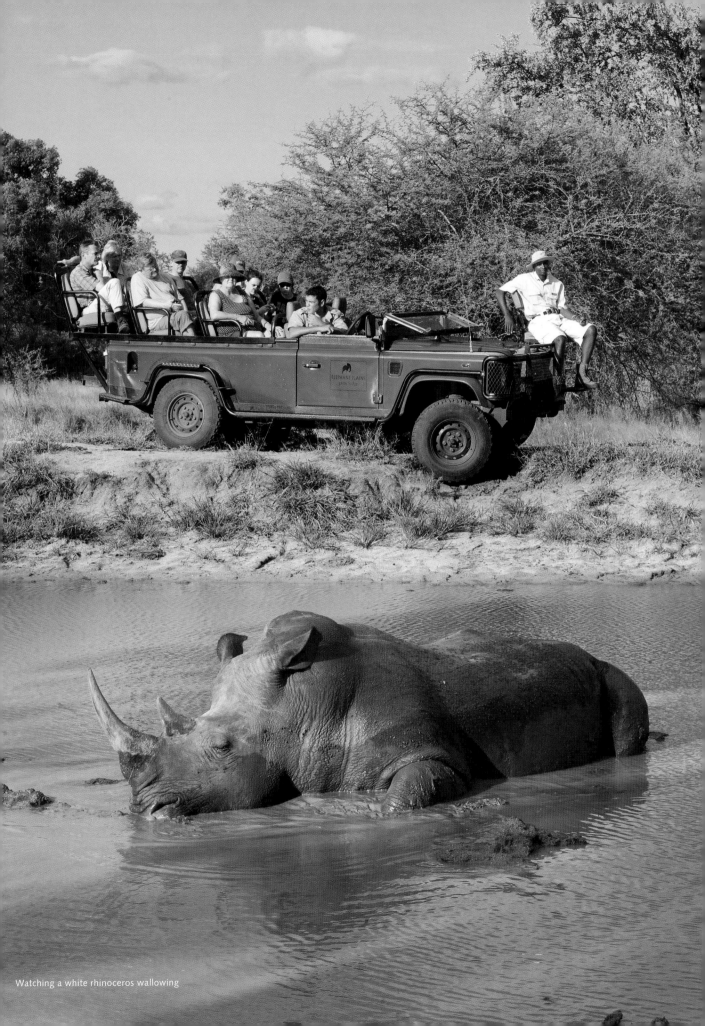

Watching a white rhinoceros wallowing

Dining under the stars

Luxury in the Bush

Location: There are luxury lodges all over South Africa
Significance: Often lodges are close to or within game reserves
Offer stylish accommodation
Ideal for guests seeking serenity and tranquillity
Many offer game drives and some have health
spas and conference facilities

In many cases luxury lodges are located in private, provincial and na-
tional game and nature reserves. In SANParks, these lodges are situ-
ated in concession areas. The development of such areas is a relatively
new concept adopted to increase public involvement in conservation.

Lodges vary from architectural masterpieces to smart safari-style
tents erected on platforms, all within beautiful natural surroundings.
Attention to detail, be it decorative, culinary or pampering, is the
order of the day. Ultra-luxury lodges offer activities tailored to indi-
vidual needs. Some lodges even have a health spa, beauty salon and
a gymnasium.

Game drives with experienced rangers and trackers on open game-
viewing vehicles are part of the luxury bush experience. These vehicles
usually have access to roadways not open to the general public, and are
also permitted to go off-road in appropriate terrain in pursuit of the
Big Five. Some lodges offer popular and relaxing activities like guided
walks, horse riding or even elephant safaris.

Interesting to know:
Lodges such as the Kapama River Lodge are designed to uplift the
guest's mind, body and soul while they unwind and enjoy being
pampered in a luxurious wellness centre. Overlooking a waterhole,
the wellness centre provides guests with the opportunity to watch
and relax in comfort as the animals come and go.

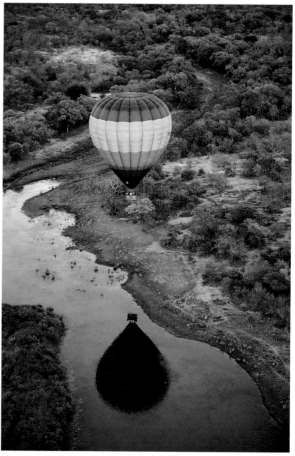
Hot-air ballooning over a game reserve

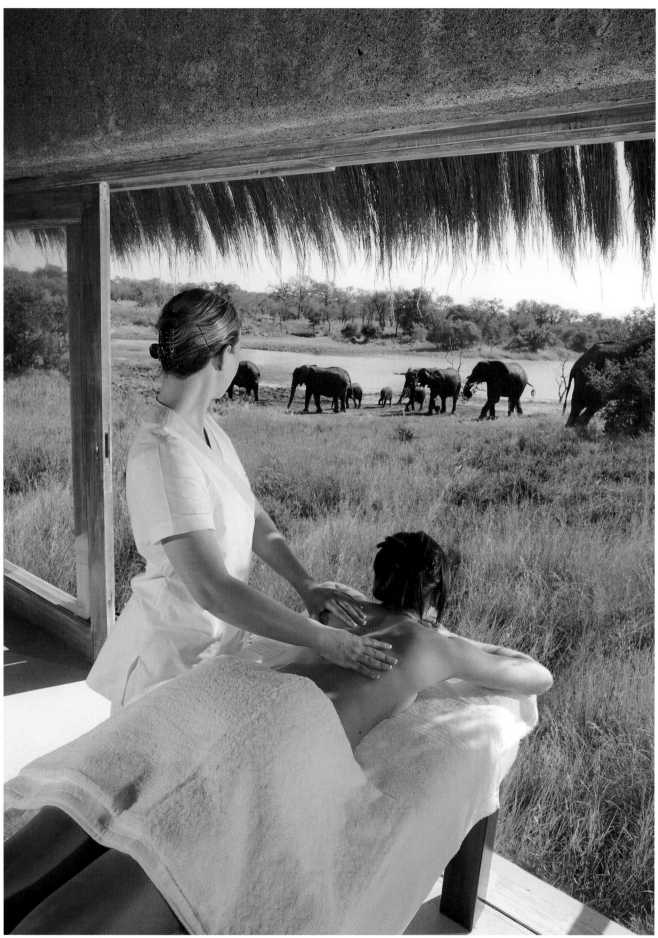

The wellness centre at Kapama River Lodge

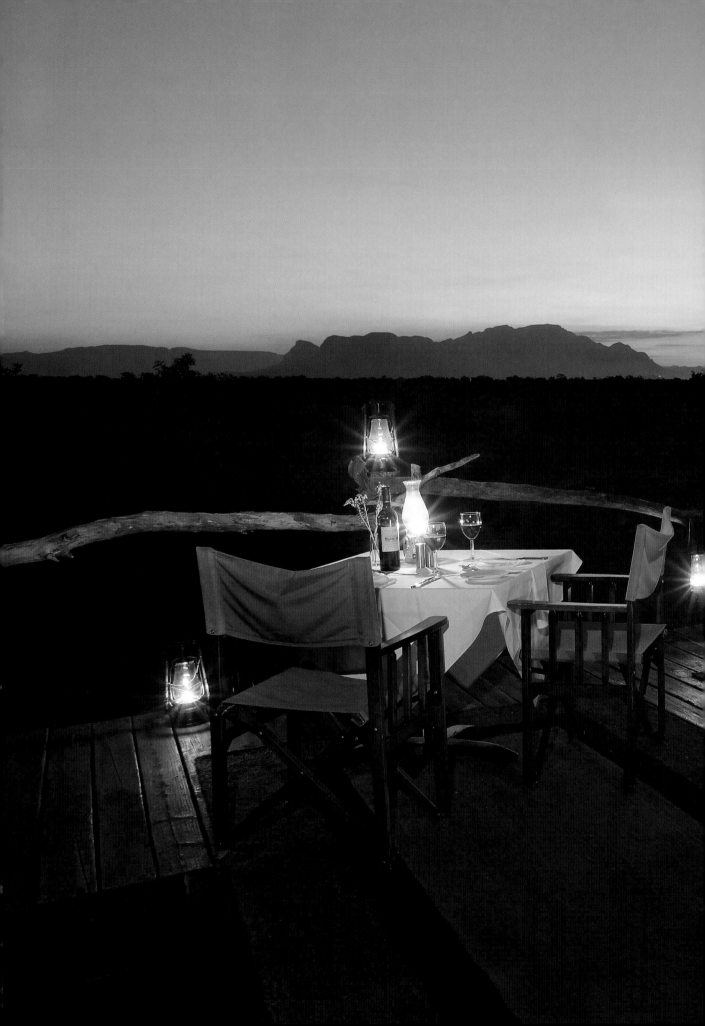

Spending a night in the open

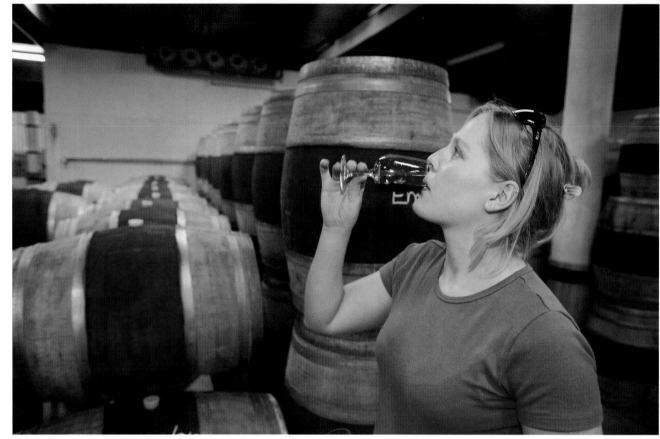

Wine Routes

Location: Comprises mainly the middle reaches of the Berg
and Breë river valleys from Tulbagh in the north
to Wellington, Stellenbosch and Franschhoek in
the south

Significance: An area well known for its wine estates
Vines planted and wine made since the 1600s

The interior of the Western Cape Province, also called the Boland, has
a Mediterranean climate and winter rainfall that lends itself to the cul-
tivation of grapes and deciduous fruits. Wine, but also table grapes,
peaches, pears and apples have made the Boland famous both locally
and internationally.

The winelands area is rich in culture and history, with numerous houses
built in the Cape Dutch style of the 17th century dotting the countryside.
This was the first area of settlement away from the Cape of Good Hope
itself. Much of the vine stock that helped establish these fine estates
originated from the peninsula's first vineyards such as those at Groot
Constantia where the stock had been brought from France.

Several good restaurants along the various wine routes tempt the
palate with traditional Cape dishes, while the landscape, fringed by the
majestic Great Drakenstein Mountains delights the eye. In addition to
award-winning red, white and rosé wines, the Boland vineyards also
produce ports, sherries and brandies.

Interesting to know:

Some of the wine routes are the Coastal Route, the Olifants Riv-
er Wine Route, the Little Karoo Route and the Constantia Valley
Route. Taking a wine tour with a touring company is one of the
ways in which this area can be explored, visiting wine farms and
tasting the estate's fare.

Hex River Valley

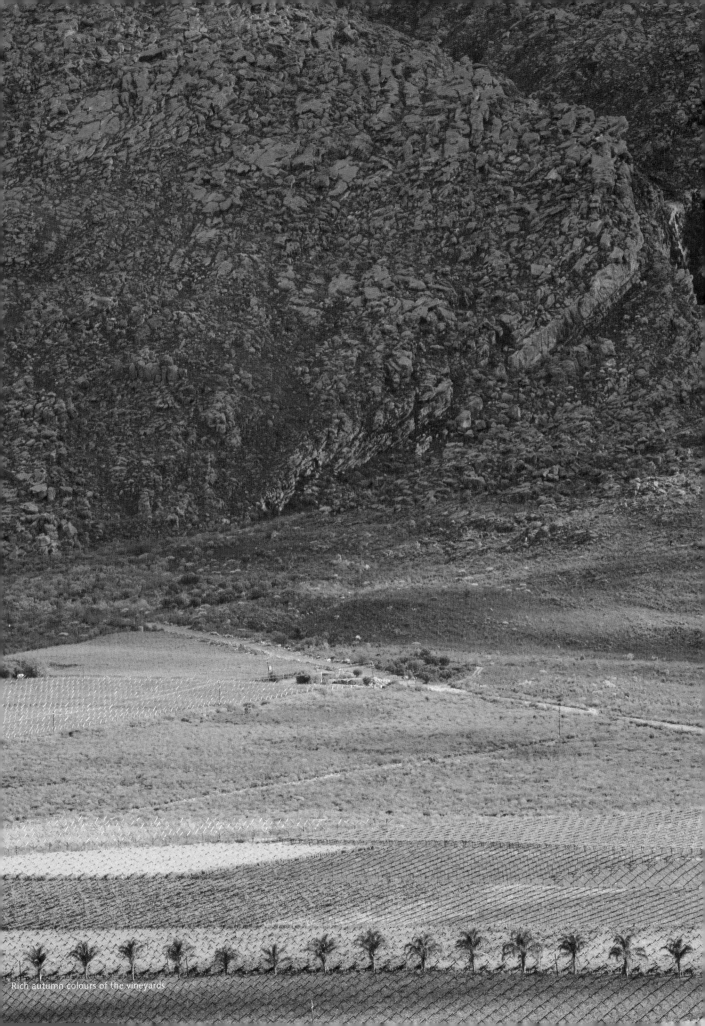
Rich autumn colours of the vineyards

Paddling the Dusi Canoe Marathon

Sporting Events

Location: World-class sports stadiums
Famous for: International sporting events – regularly hosted in the various big sporting centres

South Africans are enthusiastic about sports. By far the most popular sport is soccer or football, while rugby and cricket are next in line. Other sports in order of popularity are tennis, motor sports, athletics, wrestling and golf. The national soccer team is called *Bafana Bafana*, meaning 'the boys, the boys'. Passionate supporters often turn up at matches in costume and with painted faces, whistling, cheering and blowing on their vuvuzelas (African trumpets).

Enthusiastic preparations for upcoming national and international sporting events hosted by South Africa, always raise big expectations. The most popular homegrown internationals are the Nedbank Golf Challenge, the Cape Argus and the Cape Epic cycling events, the Comrades Marathon, the Two Oceans Marathon, the Dusi Canoe Marathon, and the Surf Ski World Cup.

Interesting to know:
South Africa has proved to be a popular host for many large sporting events. Since 1994, South Africa has hosted the Rugby World Cup 1995, African Cup of Nations 1996, IAAF World Cup in Athletics 1998, All Africa Games 1999, Cricket World Cup 2003, President's Cup 2003, Women's World Cup of Golf 2005 and 2006, Women's World Cup of Cricket 2005, A1 Grand Prix Durban 2006 and 2008, Paralympics Swimming World Championships 2007, World Twenty20 Championships 2007, Red Bull Big Wave Africa, Six-star rated Surfing Events, Confederation Cup 2009, and the Fifa World Cup 2010.

Swimming the Midmar Mile

Rock climbing at Waterval Boven

Adventure

Location: Adventure destinations – sky, water and land
Famous for: A stunning coastline and big surf
Blue skies, diverse terrain and deep caves
Sand dune landscapes
Breathtaking mountains and high rock faces
Deep gorges, white water and high bridges
Spectacular waterfalls

Undertaken at least in part for physical or emotional excitement, adventure activities in South Africa offer something for everyone, from first-timers to extreme adventurers. Choices range from laid-back stargazing or strolling, to serious hiking, mountaineering, white-water kayaking and everything in between.

For those who love adrenalin rushes, there are plenty of activities that involve exhilarating, heart-stopping experiences. Some of the most challenging extreme experiences are rock climbing and abseiling, caving, white-water rafting, wild sliding (sliding along a long steel cable over a deep abyss) and wild swinging or bungee jumping. The highest commercial bungee jump in the world, 216m, can be done from the Bloukrans bridge in the Eastern Cape.

Interesting to know:
Abseiling, or lowering oneself off the edge of a cliff down a rope, is (they say) a safe and fast way to the bottom. Incredible abseiling locations are off Table Mountain (imagine hanging in mid-air 112m above Cape Town) and dangling above crashing waves at the Knysna Heads. If abseiling is boring, what about facing the other way and rapp jumping – running down the cliff (or high building) facing forwards.

White water rafting

Hairpin bend on a mountain pass

Routes and Meanders

Location: All provinces
Significance: Scenic routes are popular for self-drive tourists
 Rich cultural experiences
 Offer a variety of attractions

Discover more about South Africa by moving out of the cities and me-
andering along back roads and lanes to experience the warm hospital-
ity of the people and the scenic beauty of the country. Many of the
well-developed tourism routes and meanders offer accommodation and
places to wine and dine, indicate historic and cultural landmarks, have
arts and crafts shops, and provide adventure, sports and leisure activi-
ties in country villages and settlements.

All the provinces give information about routes worth taking from
the main cities into the countryside. From Gauteng there are, amongst
others, the Magalies Meander, the Crocodile Ramble and the Highlands
Meander. The latter includes several towns on the highveld and is a
premier fly-fishing destination and getaway. The Panorama Route runs
along the edge of the escarpment in Mpumalanga and boasts spec-
tacular vistas, historical villages, waterfalls and the 26km-long Blyde
River Canyon.

Popular routes in the south include those in the Little and Central
Karoo, the Overberg and the West Coast. In the eastern parts there
is the Blue Crane Route, the Wild Coast Route and several others in
KwaZulu-Natal.

Interesting to know:
The Midlands Meander in KwaZulu-Natal is famous for being the
first of its kind to be established in the country. The Garden Route
and Route 62 are the most famous routes in the Western Cape.

One of the spectacular falls on the Panorama Route

The route to The Hell

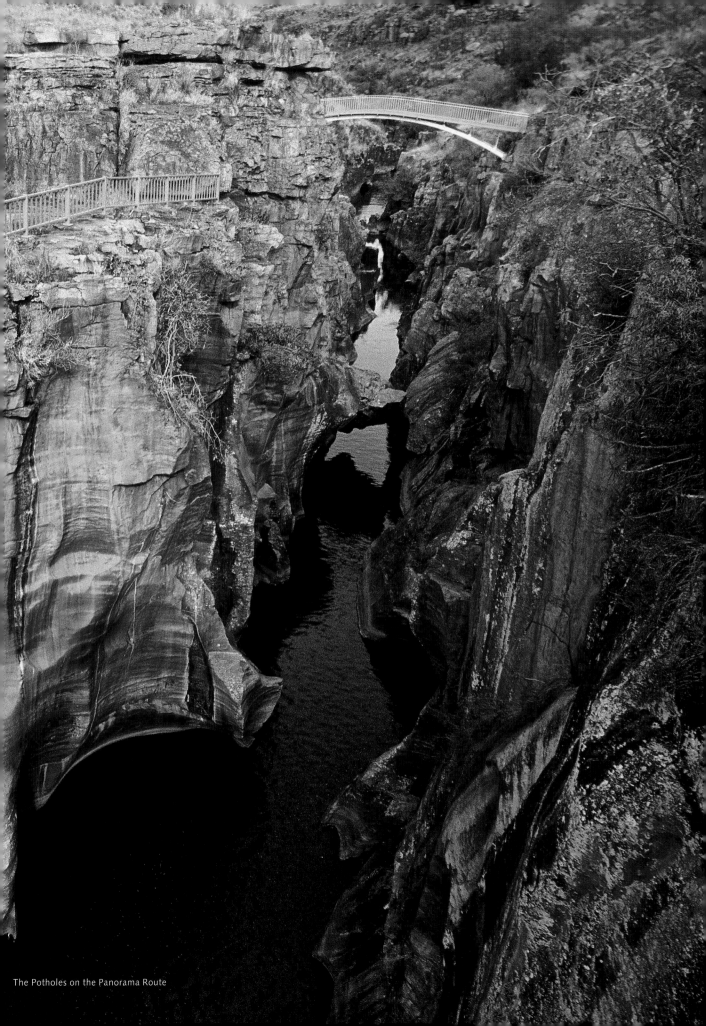

The Potholes on the Panorama Route

Cape Town Harbour at the V&A Waterfront

V&A Waterfront

Location: At the Cape Town harbour
Significance: The original harbour was built in 1860
 The Waterfront was developed in the 1980s
 Cape Town's top tourist attraction
 Gateway to Robben Island

Since the original construction of Cape Town's harbour basins in 1860, the area has been a place buzzing with activity. During the last decades of the 20th century the site was redeveloped to include a world-class entertainment and shopping complex that is also South Africa's most-visited destination. The Victoria & Alfred Dock (now the Waterfront) was named after Queen Victoria and her son Prince Alfred – the young prince visited South Africa in 1860 while the harbour basins were being built. The Victoria Basin and nearby Duncan Dock are still in use as commercial harbours.

The Waterfront has hundreds of shops and boutiques, a craft market, eateries and movie theatres. It is also home to a science exploratorium, the South African Maritime Museum, and the internationally renowned Two Oceans Aquarium. The restaurants, pubs and cafés enjoy views of Table Mountain and also of the harbour and quaysides, where boat cruises, ferries and helicopter rides can be taken.

Interesting to know:

The Nelson Mandela Gateway to Robben Island (a World Heritage Site) is situated at the V&A Waterfront, where a ferry transports people across to the island. On a tour of the island, visitors can see the prison and the cell where Nelson Mandela spent so many years.

A bridge over the canal

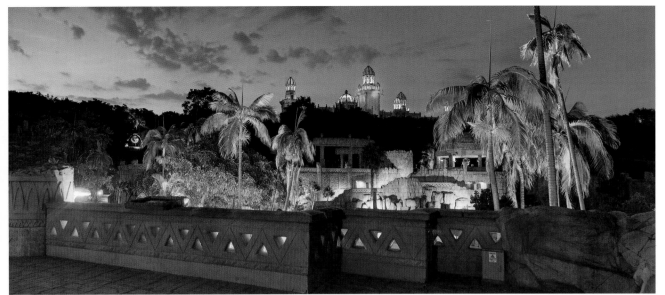

Casino Resorts

Location: There are more than 40 licensed casino resorts throughout the country

Significance: Hives of activity and good nightlife
Popular family holiday destinations
They range from the luxurious and opulent to the small and intimate

More numerous than in most European countries, South African casinos offer something for everyone. The casino at Sun City near Pilanesberg is one of the first and most famous in the country. Synonymous with luxury hotels, exotic themes and live musical entertainment, the resort has four hotels, including the spectacular Palace of the Lost City. It also has an inland rival to the ocean in The Valley of the Waves – a large pool with a wave machine and a sandy beach for sunbathing.

This casino resort nestles in natural surroundings near an ancient extinct volcano, next to the Big Five game reserve. Legend has it that an ancient people from North Africa journeyed south to build a palace for their much-loved ruler. They found this crater a suitable place to settle – a true cradle of life. Here they built a splendid palace and their king was extremely pleased. And so the palace served as the spiritual centre of their vast empire until an earthquake reduced it to ruins. Now, restored in form and rejuvenated in spirit, The Palace of the Lost City is a modern-day marvel to enchant its visitors. *That, at least, is how the story goes!*

Interesting to know:

The unique architectural styles and extraordinary decor that exude glitz and glamour at the Montecasino in Fourways near Johannesburg and at Grand West near Cape Town are difficult to match.

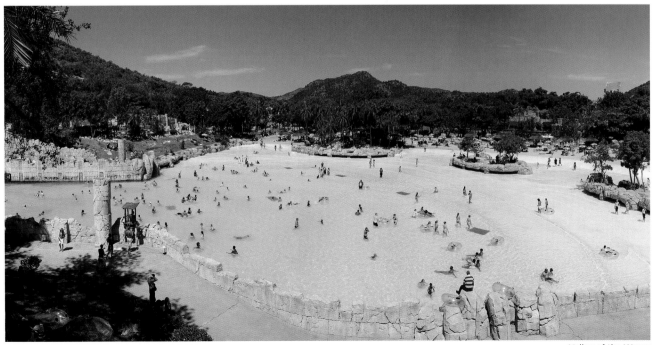

Valley of the Waves

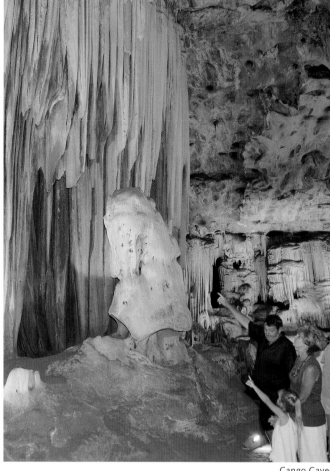
Cango Caves

Caves and Caving

Location: The Sudwala and Echo Caves in Mpumalanga
The Cango Caves in the Western Cape
The Sterkfontein Caves in Gauteng/North West

Along the Mpumalanga escarpment are hundreds of dolomitic caves. The best-known, believed to be the oldest in the world at 2 000 million years old, are the Sudwala Caves, nominated as a World Heritage Site. Centuries ago, the system of underground caverns, some 40km long, once offered a safe haven for the Pedi, Mapulane and Swazi tribes. Today 500m of the cave system is open to the public. The Echo Caves further north also sheltered humans at least since the Middle Stone Age.

The Cango Caves lie in the Swartberg Mountain Range in a limestone belt half a kilometre wide and almost 16km long. The limestone layer was formed by the deposit of loosely-bound calcium carbonate crystals. Due to the age of the limestone (750 million years old) no fossils have been found. This part of the continent was once below the ocean and the caves only started forming some 20 million years ago when upliftment occurred and the water level dropped to such an extent that the ground water could begin to seep into the limestone. As it did so, cavities were created that filled with water, which eventually flowed out about four million years ago. The caves were then exposed to air for the first time and marvellous stalagmite and stalactite formations began to form.

Interesting to know:
The famous Cango Caves are an underground wonderland of chambers and halls sculpted by nature through the ages. The fascinating limestone formations occur in a wide variety of colours and are one of the world's great natural wonders.

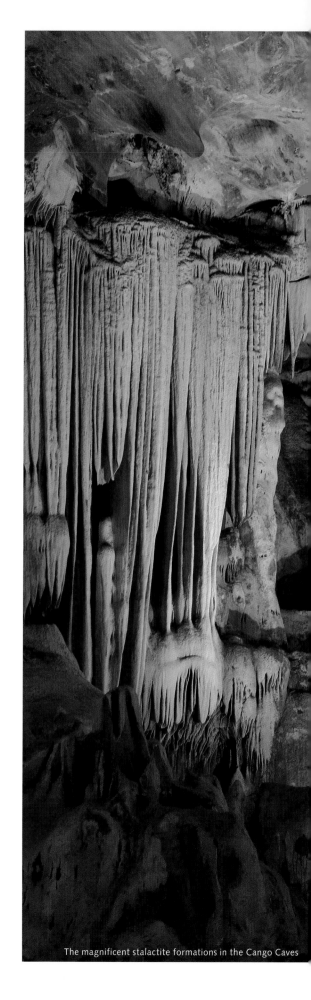
The magnificent stalactite formations in the Cango Caves

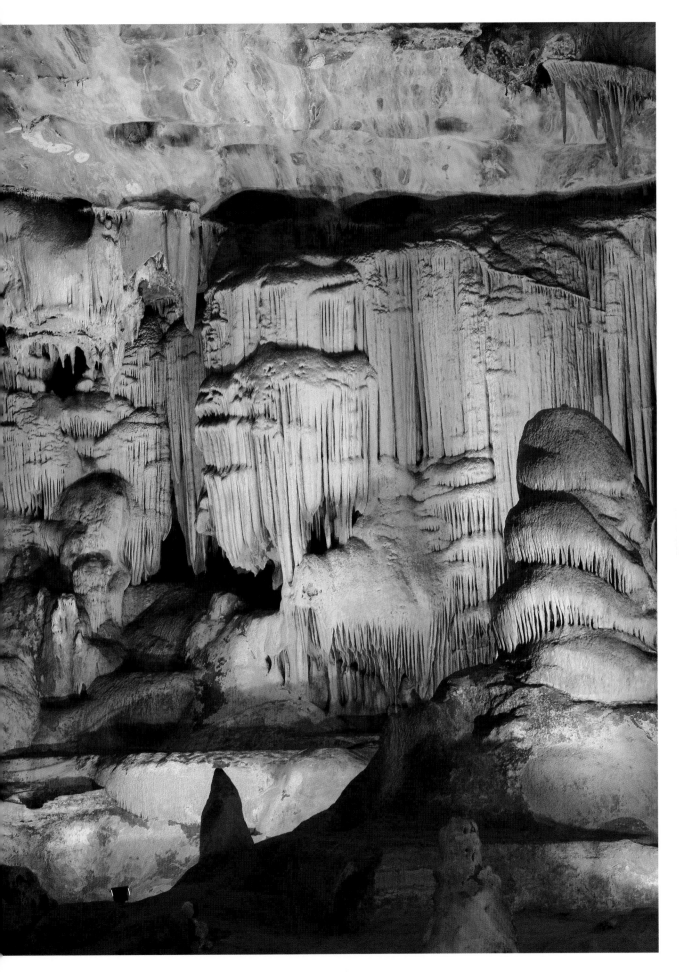

The national flag as displayed at Constitution Hill

National Pride

Unity in Diversity

The flag: Symbolises the convergence of diverse elements within South African society, taking the road ahead in unity

The motto: !ke e: /xarra //ke which in the Khoisan language means 'diverse people unite'

The coat of arms: Symbolises a united country and a prosperous nation; fertile land to feed its people; wisdom, steadfastness and strength, defending peace and honouring the first inhabitants of the land

The central image of the coat of arms is a secretary bird with uplifted wings, and a sun rising above it. Below the bird is the king protea, the national flower of South Africa, representing the aesthetic harmony of all cultures and the country flowering as a nation.

The ears of wheat are emblems of the fertility of the land, while the tusks of the African elephant symbolise wisdom, steadfastness and strength.

A shield with a spear and knobkierie (a club) above it signify peace and the protection of South Africans. These assert the defence of peace rather than a posture of war.

On the shield are rock art images of the Khoisan people, the first inhabitants of the land.

Interesting to know:
The coat of arms is a central part of the Great Seal, traditionally considered to be the highest emblem of the state. Absolute authority is given to every document with an impression of the Great Seal on it, as this means that the president of South Africa has approved it.

The South African Coat of Arms

National Anthem

Nkosi sikelel' iAfrika
(God bless Africa)

Maluphakanyisw' uphondo lwayo
(May her glory be lifted high)

Yizwa imithandazo yethu
(Hear our petitions)

Nkosi sikelela, thina lusapho lwayo
(God bless us, Your children)

Morena boloka setjhaba sa heso
(God we ask You to protect our nation)

O fedise dintwa le matshwenyeho
(Intervene and end all conflicts)

O se boloke, O se boloke setjhaba sa heso,
(Protect us, protect our nation,)

Setjhaba sa South Afrika - South Afrika!
(Nation of South Africa, South Africa!)

Uit die blou van onse hemel,
(From the blue of our heavens,)

Uit die diepte van ons see,
(From the depths of our sea,)

Oor ons ewige gebergtes
(Over everlasting mountains)

Waar die kranse antwoord gee
(Where the echoing crags resound)

Sounds the call to come together/And united we shall stan

Let us live and strive for freedom/In South Africa our lan

The anthem uses four of the country's most widely spoken 11 official languages – four lines each in isiXhosa, Sesotho, Afrikaans and English.

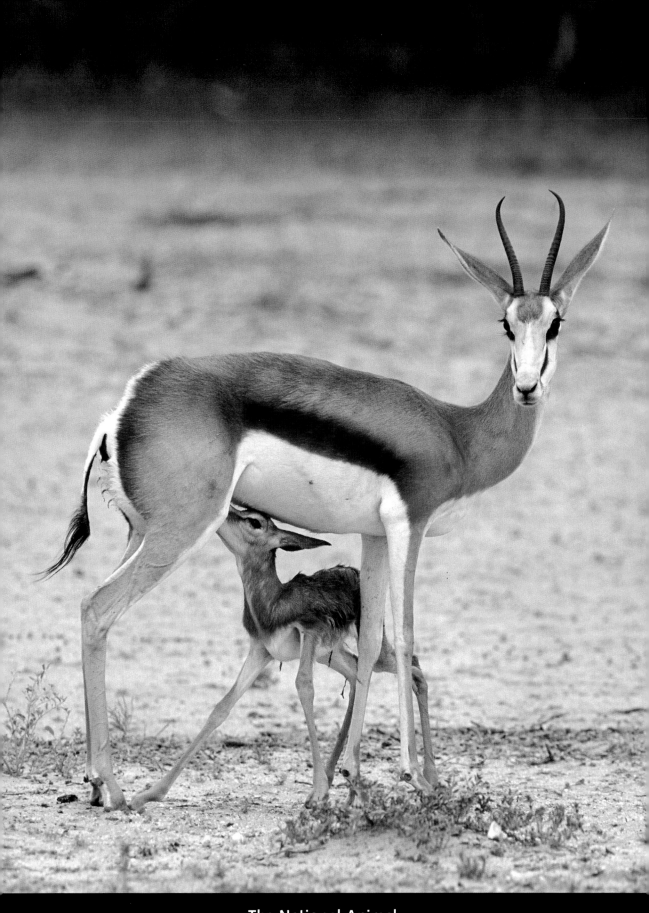

The National Animal

The National Bird
Blue Crane *(Anthropoides paradisia)*

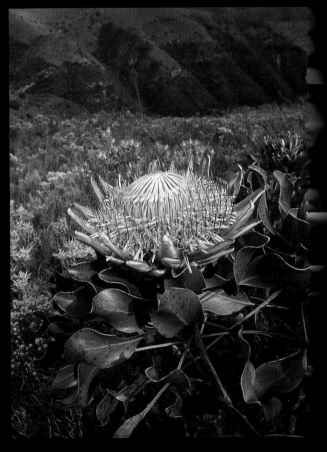

The National Tree
Real Yellowwood *(Podocarpus latifolius)*

The National Flower
King Protea *(Protea cynaroides)*

Muizenberg

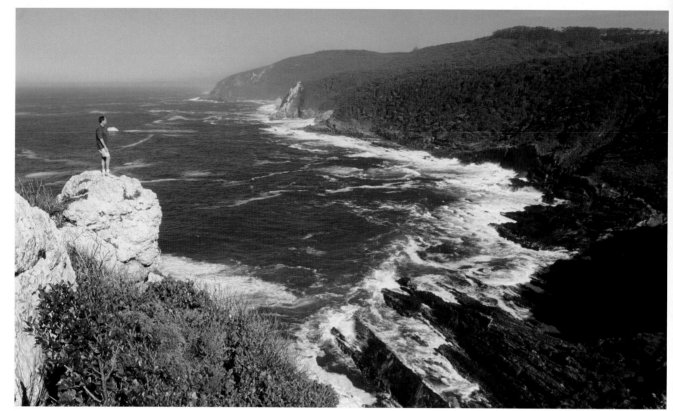

Hiker on the Otter Trail

The Van den Bergs

The Van den Bergs are an extraordinary team – photographing, writing and publishing their own books on wildlife, the environment and South Africa's diverse cultures. They have published several coffee-table, guide and memento books since 2002.

In 1997, Philip and Ingrid left the field of education to follow their dream and venture into the field of professional photography. Passionate about South Africa, their mission is to spend as much time as possible travelling around the country, meeting people, learning about cultures and studying the intricate interactions and relationships of plants and animals while keeping a photographic record of their observations.

For many years they introduced learners, educators and educational decision-makers to natural and cultural history, emphasising the importance of environmental education. They believe that people cannot care about something they do not know of and understand, and that conservation and caring for the world's wildlife and cultural heritage starts with exposure and knowledge. Their quest is to impart knowledge and reveal the wonders of the natural and cultural world through photography. This is their contribution to the conservation of an extraordinary heritage.

After winning several national and international photographic awards, Heinrich left a career in engineering to pursue his interest in photo-journalism. Already an internationally-acclaimed photographer, he has effortlessly applied his technical knowledge to master the skills associated with publishing. In addition to the photography, he does all the designing and reproduction for the books, and oversees the printing process in Singapore.

ISBN: 978-0-9946924-3-6
Revised edition 2017
Published by **HPH Publishing**
50a Sixth Street
Linden, Johannesburg
info@hphpublishing.co.za
www.hphpublishing.co.za
Tel: +27 86 171 0327
First published in 2009
Copyright © **HPH Publishing**
Text by Ingrid van den Berg and Joanne Pohl
Statistics and information from:
International Marketing Council of South Africa
and www.southafrica.info
Photography by Heinrich van den Berg, Philip & Ingrid van den Berg
p14, p17, p30 and p36 by Jay Roode
Edited by John Deane and Gillian Paizes. Proofread by Gillian Paizes
Design, typesetting and reproduction by Heinrich van den Berg
Printed and bound by Tien Wah Press (Pte.) Ltd